Voyages & Visio

Nineteenth-Century European Imag
of the Middle East
from the
Victoria and Albert Museum

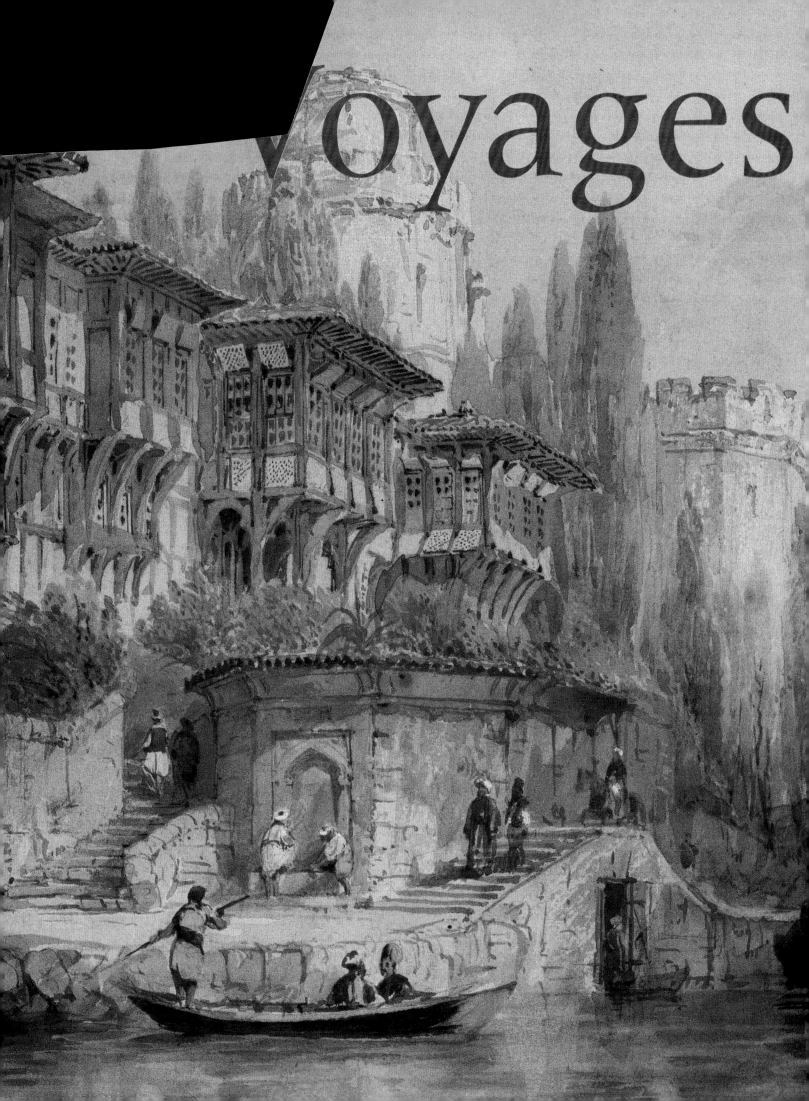

Voyages

& Visions

Nineteenth-Century European Images

of the Middle East

from the

Victoria and Albert Museum

Esin Atil

Charles Newton

Sarah Searight

Smithsonian Institution Traveling Exhibition Service
WASHINGTON, D.C.
and
THE VICTORIA AND ALBERT MUSEUM
LONDON
in association with
UNIVERSITY OF WASHINGTON PRESS
SEATTLE AND LONDON

Published on the occasion of an exhibition organized
by the Smithsonian Institution Traveling Exhibition
Service in association with the Victoria and Albert
Museum. The exhibition and its educational programs
have been made possible by a generous grant from The
Boeing Company. Funding in support of the publication
has been provided by Shell International Petroleum
Company Limited. Additional funding has been given
by the Drue Heinz Foundation and The British Council.

Hardcover edition distributed by
University of Washington Press
P.O. Box 50096

Library of Congress Cataloging-in-Publication Data

Victoria and Albert Museum.
 Voyages & Visions : nineteenth-century
European images of the Middle East from the
Victoria and Albert Museum / Esin Atıl, Charles
Newton, Sarah Searight.
 p. cm.
 Exhibition catalog.
 "In association with University of Washington
Press, Seattle and London."
 Includes bibliographical references and index.
 ISBN 0-295-97490-7 (hardback)—
 ISBN 0-86528-042-8 (paperback)
 1. Exoticism in art—Europe—Exhibitions.
 2. Middle East in art—Exhibitions. 3. Art, Euro-
pean—Exhibitions. 4. Art, Modern—19th cen-
tury—Europe—Exhibitions. 5. Art—England—
London—Exhibitions. 6. Victoria and Albert
Museum—Catalogs. I. Atıl Esin. II. Newton,
Charles. III. Searight, Sarah. IV. Title
N8217.E88V53 1995
758' .9956—dc20 95-32276
 CIP

COVER: DETAIL OF PLATE 8

Entrance to the Golden Horn, Istanbul

PAGES 2-3: DETAIL OF PLATE 20

Summer Pavilions and Rumeli Hisarı on the

Bosphorus, with Anadolu Hisarı in the Distance

CONTENTS

Located at the crossroads of Europe and Asia, and along the route from the Black Sea to the Mediterranean, Istanbul (formerly called Byzantium and later Constantinople) was a center of seafaring trade. By the nineteenth century, the city had grown on both sides of the channel known as the Bosphorus. An inlet of the Bosphorus, the Golden Horn, provided a safe natural harbor on the European side. *(Pls. 1, 2)*

PLATE 1
Istanbul and the Bosphorus
Attributed to Giuseppe
Schranz (1803-post 1853)
c. 1835
Pencil and watercolor,
heightened with white
25.0 x 44.5 cm

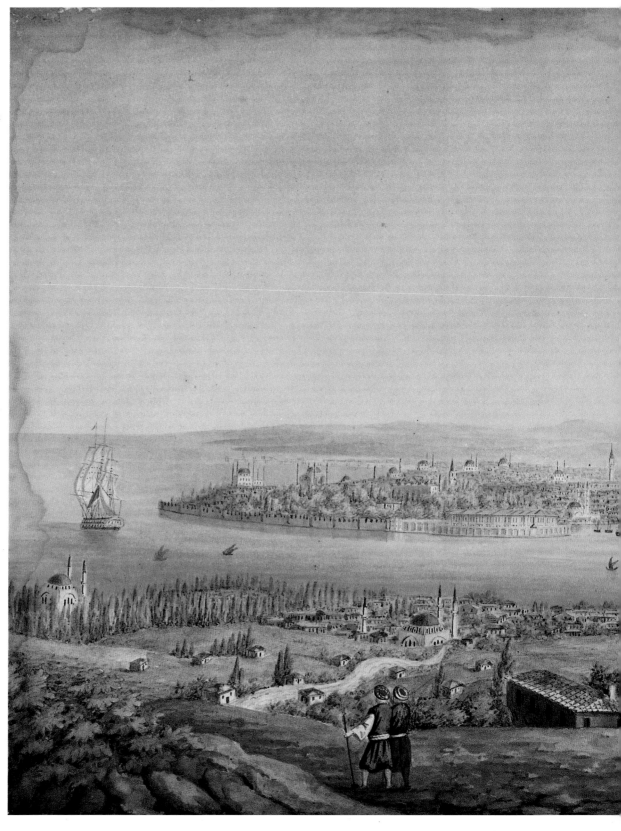

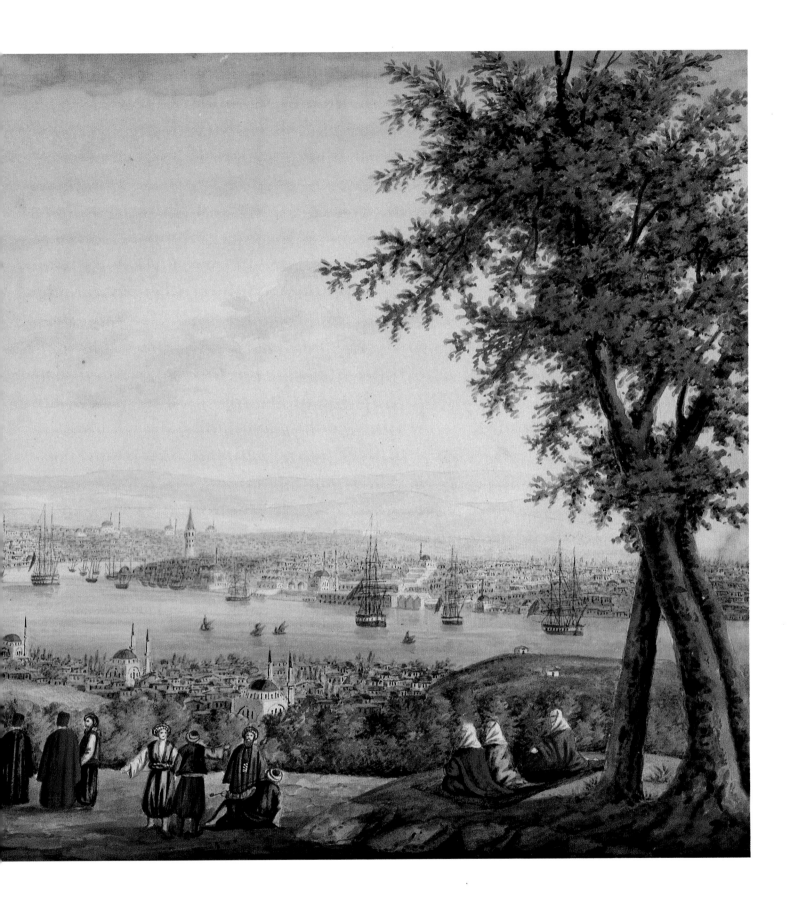

EDITORIAL NOTE

Modern forms and spellings for personal and place names have been used in the catalogue, and standard American English usage has been observed. The preferred Arabic system of transliteration is used for Arabic words, Persian for those of Persian origin, and modern Turkish for Ottoman Turkish terms. Diacritical marks are not used in the transliteration of Arabic and Persian words and names.

Abbreviations after an artist's name indicate membership in the following British societies:

FRGS	Fellow of the Royal Geographical Society
FRIBA	Fellow of the Royal Institute of British Architects
FSA	Fellow of the Society of Antiquarians
NWS	New Water Colour Society
OWS	Old Water Colour Society
RA	Royal Academy
RBA	Society of British Artists
RI	Royal Institute of Painters in Water Colours
RWS	Royal Society of Painters in Water Colours

A "P" preceding these abbreviations indicates that the artist served as president of that society.

Unless otherwise stated, the works are on white, cream, or buff wove paper. In most cases, the dimensions are those of the drawn area. When the image is not clearly defined, the sheet size is given. Dimensions are in centimeters, height preceding width.

Further information about the works, such as provenance, exhibitions, and literature, is to be found in the microfiche catalogue of the Searight Collection, available in the Print Room of the Prints, Drawings, and Paintings Collection at the Victoria and Albert Museum.

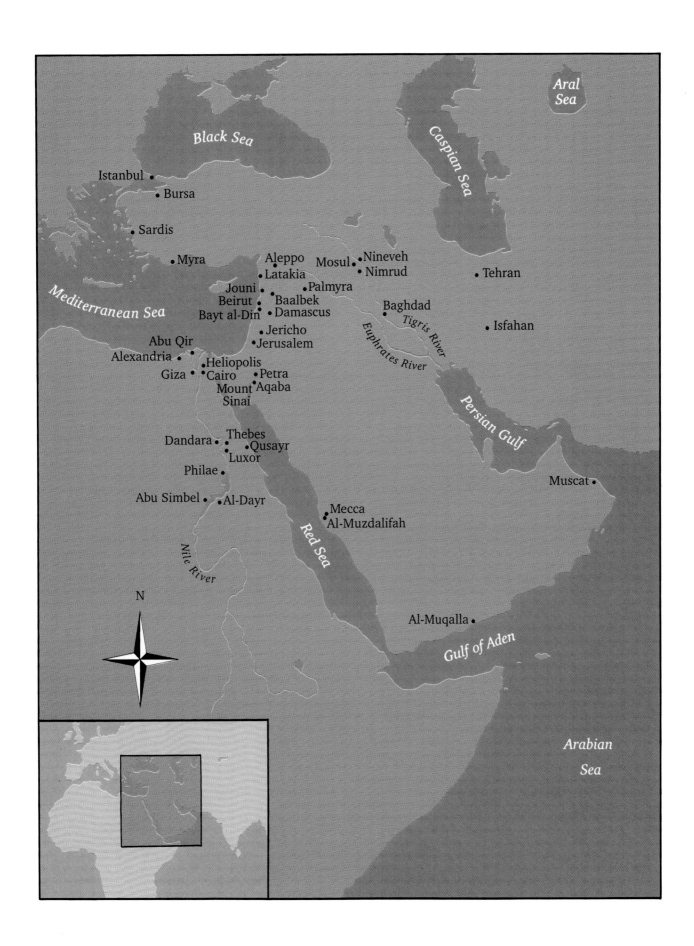

Black Sea

Aral Sea

Caspian Sea

Istanbul

Bursa

Sardis

Myra

Aleppo
Mosul
Nineveh
Nimrud

Tehran

Latakia

Mediterranean Sea

Jouni
Beirut
Bayt al-Din

Palmyra

Baalbek
Damascus

Baghdad

Isfahan

Tigris River

Euphrates River

Jericho
Jerusalem

Abu Qir

Alexandria

Heliopolis

Giza

Cairo

Petra

Mount

Aqaba

Sinai

Persian Gulf

Muscat

Dandara

Thebes

Qusayr

Luxor

Philae

Abu Simbel

Al-Dayr

Red Sea

Mecca
Al-Muzdalifah

Nile River

N

Al-Muqalla

Gulf of Aden

Arabian
Sea

9

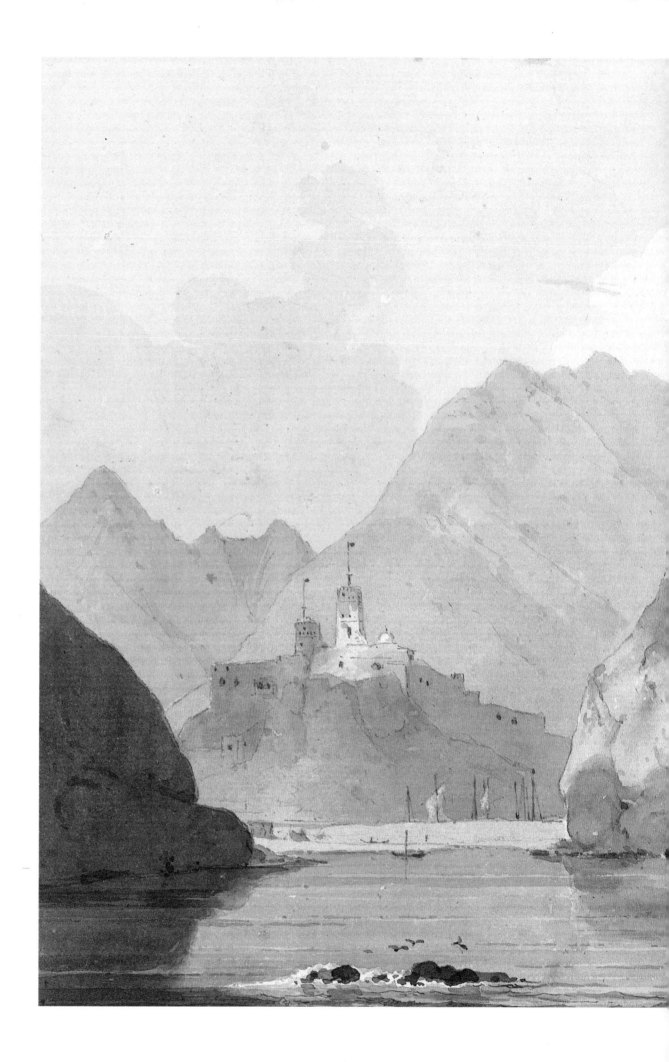

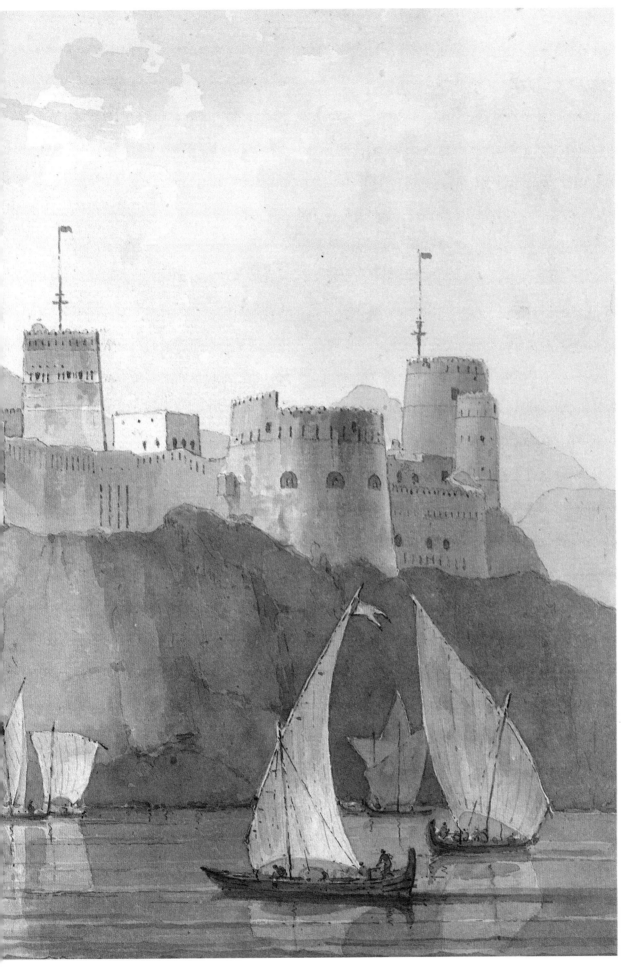

PLATE 2
View of the Forts of
Marani and Jalali at the
Entrance to Muscat Harbor
William Daniell RA
(1769-1837)
1793
Pencil and watercolor, on
laid paper
22.3 x 30.8 cm

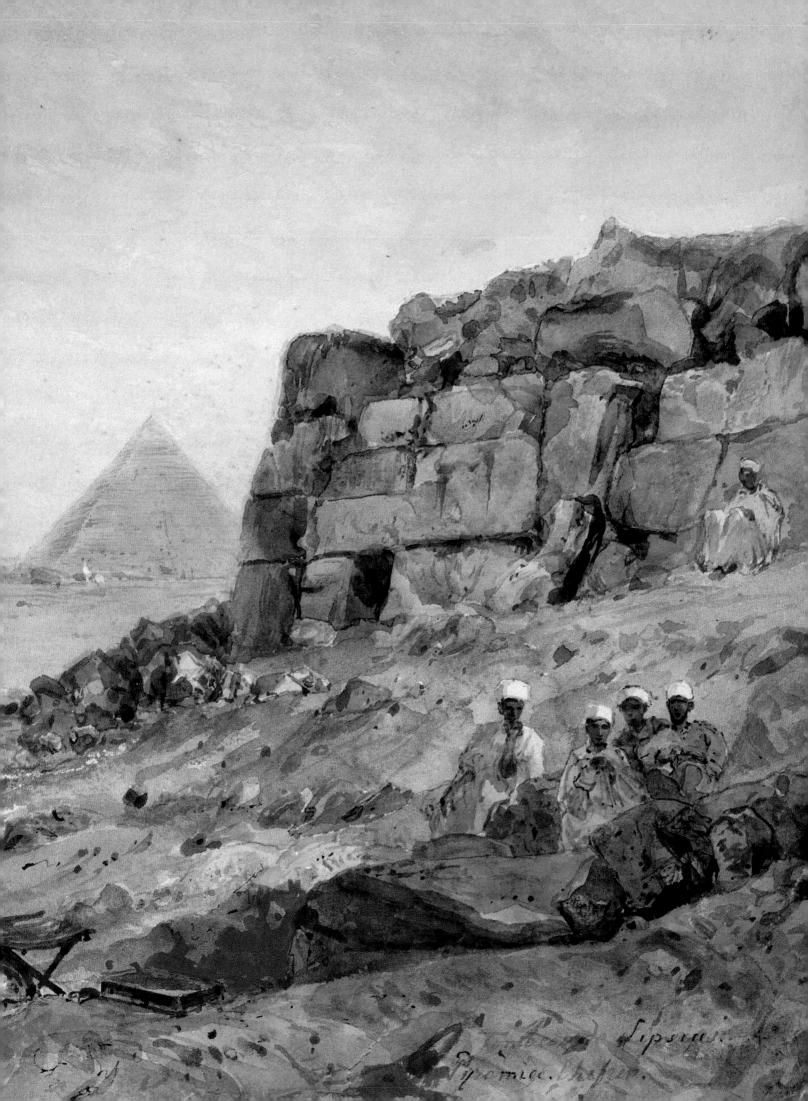

INTRODUCTION

Donald Roberts McClelland

Centuries before the dawn of the ancient Greek civilization, the lands known today as the Middle East were the stage for some of the world's earliest intellectual and philosophical developments. European fascination with the grand architecture, dramatic landscapes, and exotic cultures of this diverse region, stimulated by the Crusades of the eleventh and twelfth centuries, extended well into the nineteenth century. Contact between East and West had been intermittent and circumscribed at best, but tales of these distant lands had nevertheless fueled many romantic notions of the Ottoman and Mamluk empires and had enhanced the powerful allure of the Islamic world.

With the landing of Napoleon Bonaparte and his army at Alexandria, Egypt, on 1 July 1798, European interest in the East expanded beyond trade to include a scientific and technological bent. Included in Napoleon's expedition were able military engineers, scientists, scholars, and topographical artists who analyzed and recorded all facets of their intriguing surroundings. Once back in Europe, their findings, journals, and artworks were enthusiastically received by those eager for information and entertainment. As travel to Asia and Africa became easier and the geopolitical importance of the region increased, curiosity about the East mounted.

Visitors to the Middle East during the nineteenth century ranged from diplomats and men of commerce, to scholars, historians, writers, and pilgrims intent on seeing the sites holy to the area's great religions: Islam, Judaism, and Christianity. Initially artists joined these travelers on their tours of historic and religious locations to fulfill specific commissions. As the century progressed, artists frequently roamed the land in search of their own personal inspiration, looking for scenes that stimulated the senses and captured the imagination. Topographical artists considered themselves instrumental in the pursuit of knowledge, documenting remains of the ancient past and the current face of the landscape. Others attempted to portray faithfully the rich diversity of the native peoples and their customs. Far too many used their art to feed into exaggerated European notions of fanciful harems and elaborate architecture. Watercolor became the medium of choice. More portable and quick drying than oils, it was eminently practical for sketching. When used in combination with pencil, pen and ink, gouache, or chalk, watercolors could be employed to add random observations in a sketchbook or to produce a finished work on the spot.

Donald Roberts McClelland is Assistant Director for Programs, Smithsonian Institution Traveling Exhibition Service.

PAGES 14-15: PLATE 3
Monastery of Saint Catherine, Mount Sinai
Richard Beavis RWS
(1824-1896)
1875
Pencil, charcoal, and watercolor, heightened with white
35.4 x 52.7 cm

DETAIL OF PLATE 79
Pyramid of Chephren, Giza

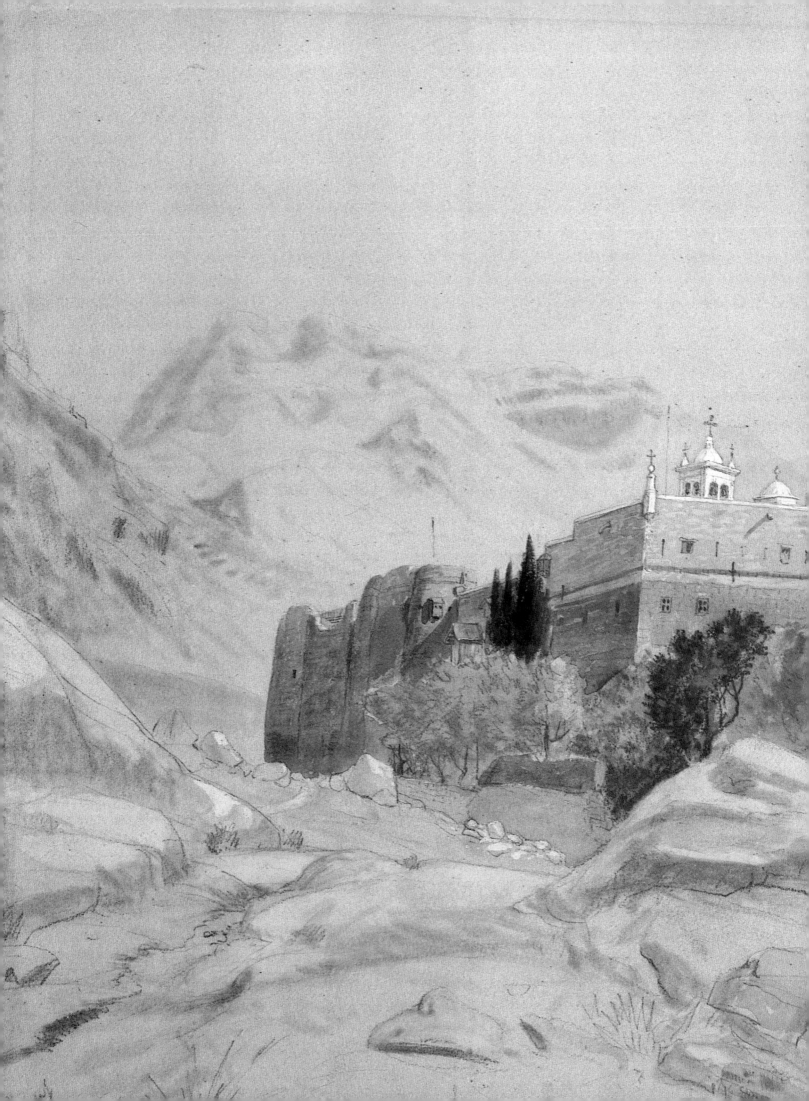

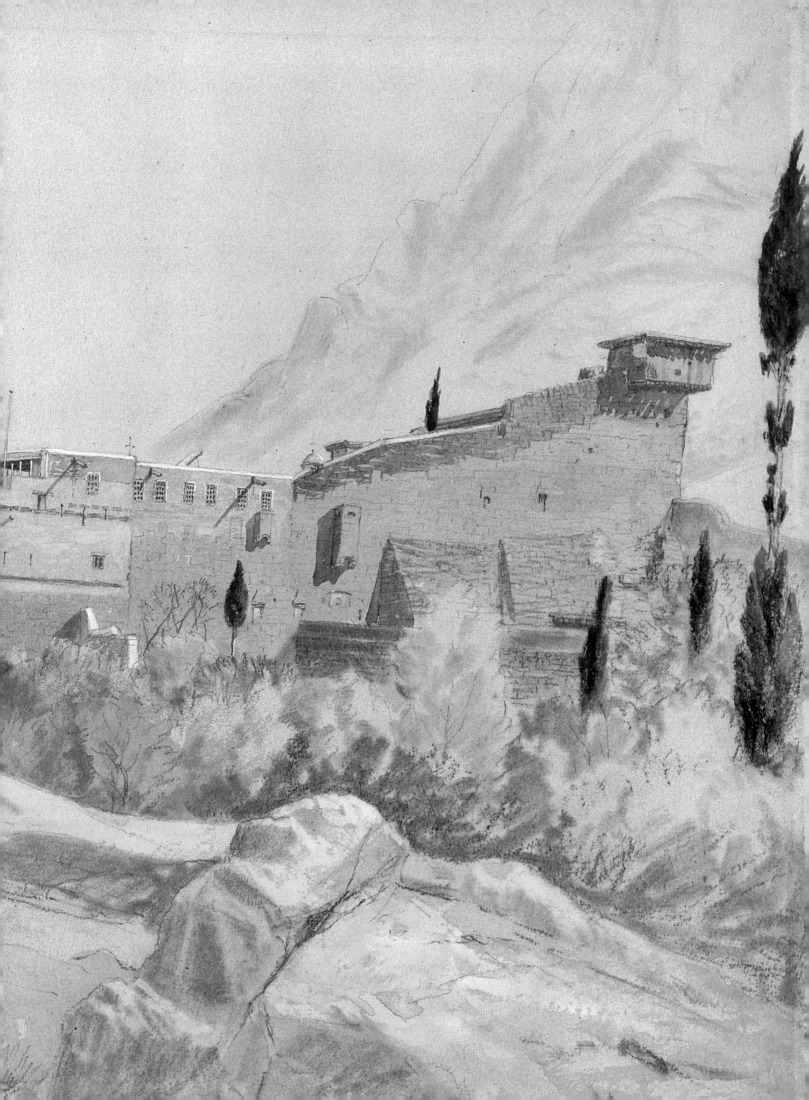

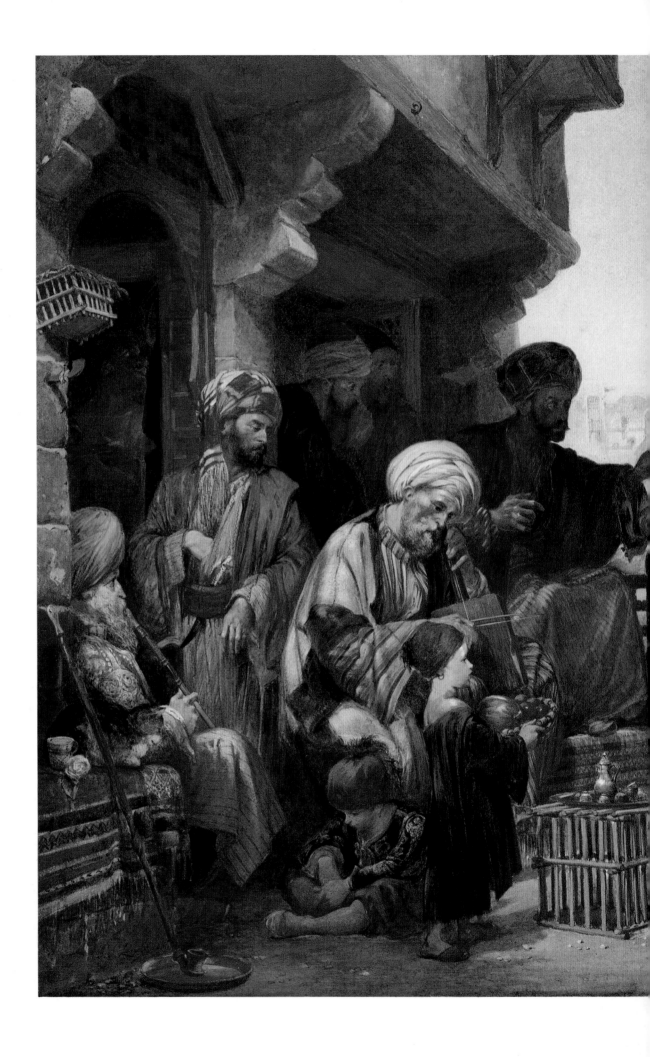

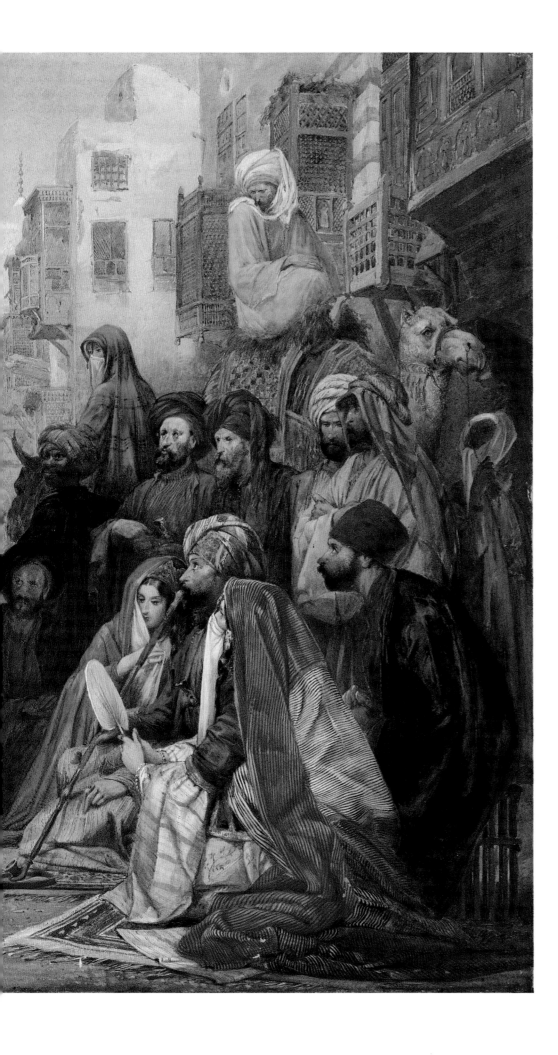

PLATE 4
Scene in a Cairo Bazaar
John Frederick Lewis RA
POWCS (1805-1876)
1856
Watercolor and gouache,
heightened with white
45.5 x 59.6 cm

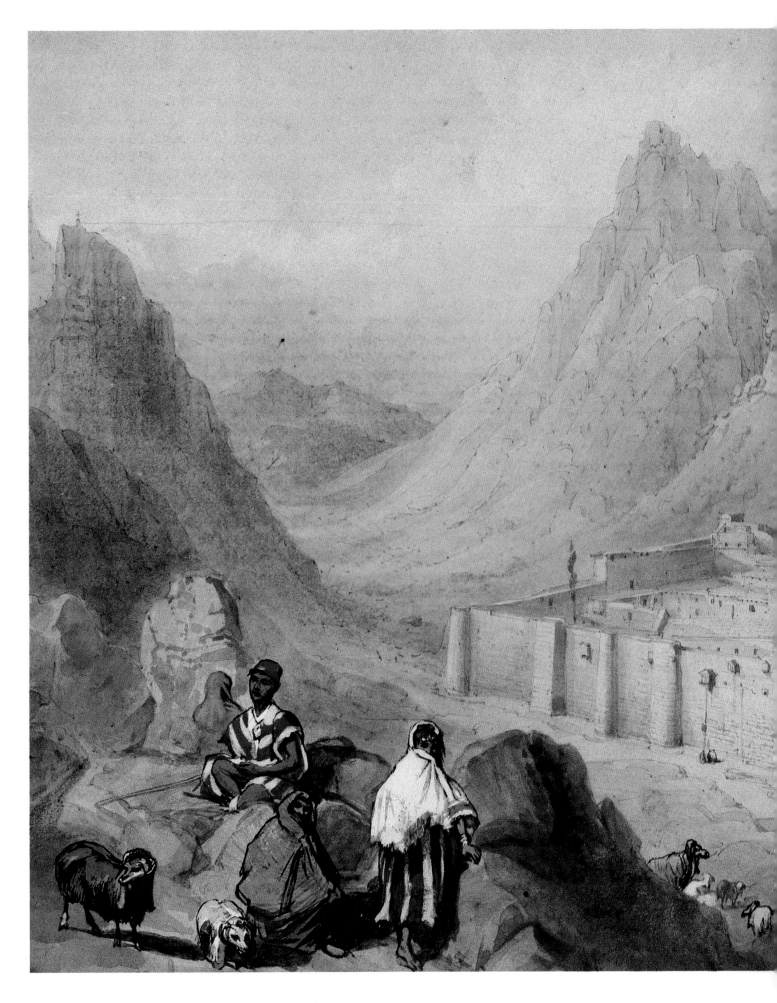

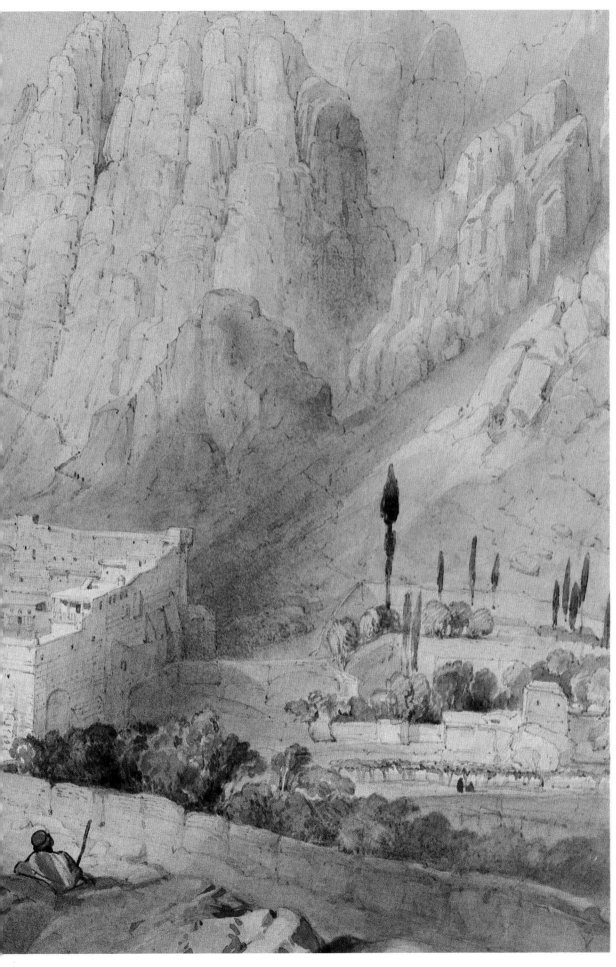

PLATE 5
Monastery of Saint Catherine, Mount Sinai
William Henry Bartlett
(1809-1854)
c. 1848
Pencil, watercolor, and gouache, with pen and ink, heightened with white
21.1 x 34.6 cm

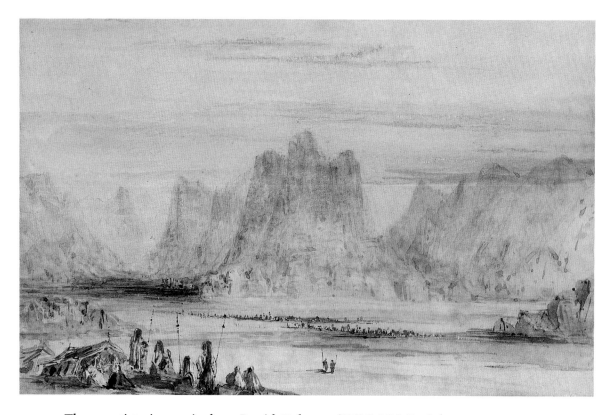

Three artists in particular—David Roberts (1796-1864), John Frederick Lewis (1805-1876), and Edward Lear (1812-1888)—illustrate ways in which the Middle East played a major role in the Western imagination of the nineteenth century. Instilled in the romantic movement, each of these British artists valued the sublimity both of the great structures of classical antiquity and of the natural environment. Roberts, a well-established topographical artist by the time he first visited Cairo in 1838 (pl. 73), inflected his experience with typically romantic emotions, writing that he was "overcome by melancholy reflections on the mutability of all human greatness."[1] Lewis's subdued palette came to incorporate dramatic, bright washes of pure blue, yellow, and red in response to the new observations of light he garnered in Cairo, the Sinai, and the valley of the Nile (pl. 4). Lear, who first journeyed to Egypt in 1846, stood in awe of the daunting antiquity of Pharaonic monuments. He wrote of Luxor, "The intense deadness of old Egypt is felt as a weight of knowledge in all that world of utter silence . . . when one peeps into those dark, death-silent, giant halls of columns, a terror pervades the heart and head."[2] All of them attempted to record the vast dimensions of the exotic world in which they traveled. Such aspirations resulted in special documents of the European romantic age and its encounter with the Middle East.

Like so many foreign travelers in the nineteenth century, Roberts, Lewis, and Lear each trekked to the great fortress monastery of Saint Catherine, located in the remote southern mountains of the Sinai peninsula. Surrounded by desert wilderness and sharp granite mountains, the monastery had been safeguarded by nature from the destructive military battles that had long plagued this area at the crossroads of Asia and Africa. Both fortress and church were built between 548 and 565 by Justinian the Great to protect monks from marauding tribes and to preserve the location that was widely accepted as the site of the biblical burning bush. The church would later enshrine the relics of Saint Catherine of Alexandria, an early Christian martyr.

20

Artist Richard Beavis (1824-1896) first visited the monastery in October 1875 and painted a dramatic view of the fortress (pl. 3). He delineates the bell tower at the center, and to the right, the shallow dome of a minaret that stands adjacent to the mosque, which was erected within the fortress walls between the tenth and twelfth centuries and is still in use today. The dark, rounded fortifications to the far left originated from the late eighteenth century, when Napoleon sent General Jean Kléber to restore the fortress, which had been damaged by an earthquake some years earlier. To the right looms the Mount of Moses, while in the foreground the land slopes gently down to the Plain of Raha, traditionally cited as the place where the Israelites camped while Moses ascended the mountain's summit.

More than one hundred years later, the monastery in Beavis's watercolor closely resembled the site I visited in my own search for scholarship and adventure in these ancient lands. I remember the lower Sinai as a harsh desert dotted with rocks and camel thorn, acacia, tamarisk, myrrh, and thyme, all stretching out beneath a hard blue sky. The spiritual significance of Saint Catherine's still forges a vital link with the past that is further bolstered by its magnificent icons and mosaics and its astounding collection of ancient manuscripts.

Rodney Searight (1909-1991), who amassed the distinguished collection upon which this exhibition is based, was moved as I was by the rich history and artistic importance of the region. Searight, a man of commerce who was first posted to Egypt in 1931, was steeped in the enlightened tradition of inquiry into all subjects. He became an expert in the lands and cultures of this area. He brought to his collecting a skilled eye and a passionate sensibility, which influenced his keen selection of views of the grand architecture and dramatic landscape of an earlier era. Indeed, many of the great monuments of Islamic architecture had disappeared by the mid-twentieth century, and Searight, like so many artists before him, wanted to save for posterity a part of that glorious past. His extensive collection of watercolors and drawings entered the collections of the Victoria and Albert Museum in London in 1985.

Searight's efforts to preserve visual records of the past, which were shaped by the experiences of various Western artists traveling throughout the East, provide the context for the essays in this catalogue. In surveying the Ottoman culture of the nineteenth century, Dr. Esin Atıl poses intriguing counterpoints and defines areas of mutual exchange and influence between East and West. Sarah Searight charts the historical course of European travel to the Middle East, emphasizing the evolution of trade and commerce, the impact of industrial and technological innovations, and changes in the geopolitical importance of the region. Charles Newton addresses the artists themselves and their variety of responses to the exotic lands they encountered on their distant travels. Together, these images and essays introduce us to worlds that have, in part, disappeared, and to sites, like the majestic monastery of Saint Catherine, that continue to inspire new generations of travelers.

Notes

1. James Ballantine, *The Life of David Roberts, R.A., Compiled from his Journals and Other Sources* (Edinburgh, 1866), p. 89.

2. Vivien Noakes, *Edward Lear: The Life of a Wanderer* (London, 1968), p. 215.

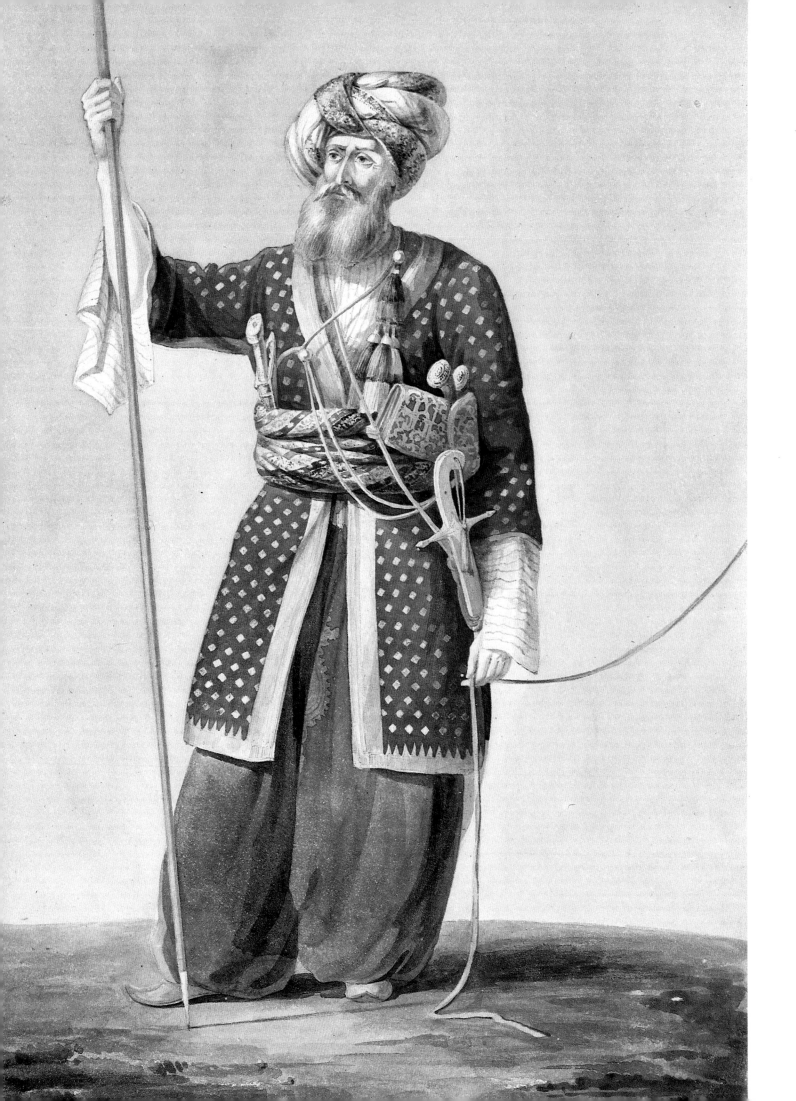

THE OTTOMAN WORLD IN THE NINETEENTH CENTURY

Esin Atıl

Dr. Atıl is specialist of Islamic arts and cultures, Arthur M. Sackler Gallery and Freer Gallery of Art, Smithsonian Institution, Washington, D.C.

The nineteenth century was a fascinatingly heterogeneous period with intercontinental styles in art and architecture. Certain districts in metropolitan Istanbul and Cairo built in this era, with uniform rows of apartment houses and central parks embellished with fountains, could not be differentiated from contemporary streets and squares in European capitals. Private dwellings in fashionable nineteenth-century suburbs of New York, London, Stockholm, Istanbul, Beirut, Alexandria, and Tunis display numerous common features in their architectural layouts, exterior decorations, and interior furnishings that not only present similar configurations of "Oriental" and "Occidental" elements but also reflect similar lifestyles and aesthetics. European or European-trained architects and decorators were hired to build and furnish the villas and mansions of wealthy residents of northern Africa and western Asia, and American and European patrons favored Islamic styles in their estates to flaunt their worldliness.

European and American travelers to Asia and Africa found both familiar and novel conditions, as did those coming from Asia and Africa to visit Europe and North America. Both groups stayed in hotels replete with identical settings and services, indulged in continental foods and beverages, and discussed the same controversial world issues with their hosts. These travelers were, however, in search of the esoteric, visiting Montmartre in Paris and the Old Bazaar in Istanbul, and taking excursions to Stonehenge in Salisbury and the Valley of the Kings in Luxor. One must admit that the Islamic lands had more exotic experiences to offer, ranging from snake charmers and belly dancers to ancient ruins and biblical sites. Few things could compare with the pomp and ceremony of an imperial reception in Istanbul or the sunset at Petra, where the cliffs turn crimson when the last rays of the sun hit the rock-cut structures.

World fairs, which became fashionable in Europe after the mid-nineteenth century, helped to popularize the diverse cultures of Asia and Africa. The impact on European architecture was immediate, with domed pavilions resembling miniature mosques and baths appearing on large estates, and Turkish rooms and moresque accessories abounding in grand homes. Artists such as Emile Gallé, Henri Brocard, Edmé Samson, and Théodore Deck of France; the Cantagalli workshop of Italy; William Morris of England; and Peter Carl Fabergé of Russia made enameled and gilded glassware, underglaze-painted ceramics and tiles, and

PLATE 7
Mamluk from Aleppo
William Page (1794-1872)
c. 1817
Pencil and watercolor, heightened with white
37.7 x 26.4 cm

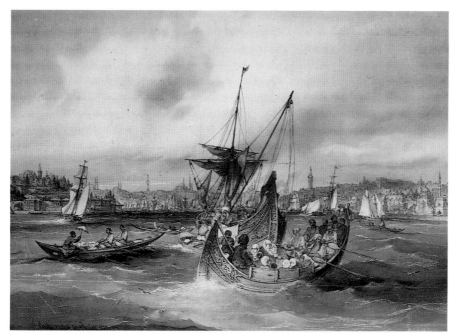

PLATE 8
Entrance to the Golden Horn, Istanbul
Amadeo, Fifth Count Preziosi (1816-1882)
1853
Pencil and watercolor, heightened with white
51.5 x 72.5 cm

OPPOSITE: PLATE 9
The Favorite Odalisque
Thomas Allom FRIBA
(1804-1872)
c. 1840
Pencil and watercolor
29.6 x 21.4 cm

gem-encrusted gold and silver items, using as their models fourteenth- to sixteenth-century examples created in Egypt and Turkey. Some of these recreations were so expertly made that they were mistaken for originals.

Glass factories in Bohemia and Venice, and porcelain workshops in Meissen and Vienna, were manufacturing wares with European designs for the Islamic markets while producing goods with Islamic themes and motifs for their European customers. European glass and porcelain were so much in demand by the Ottomans that the sultan established ateliers supervised by foreign masters to satisfy the needs of the court and to train local artists.

The interest in the Ottoman world also affected European literature, theater, music, and social activities. Operas and plays featuring Islamic heroes and heroines, orchestral compositions based on the melodies and instrumentation of western Asian music, and gala affairs with Turkish costumes further helped to popularize the movement in Europe. In turn, programs with European music were offered to the public in Istanbul and Cairo: Liszt performed at the Beşiktaş Palace in Istanbul, and Verdi's *Aïda* was inaugurated in Cairo.

Improved diplomatic relations between the Ottoman Empire and European nations led to the opening of large embassies, while the development of railways and steamships provided favorable traveling conditions, which resulted in unprecedented traffic between Europe and Asia. Travel was further stimulated by archaeological expeditions that unearthed such ancient civilizations as Hittite, Pharaonic, Greek, and Roman. Serious scholarship began with the establishment of French, British, German, American, and other national schools of western Asian studies.

Art exhibitions, scholarly conferences, popular travelogues, serious archaeological surveys—plus confidential military and political reports gathered by the embassies—all contributed to the intercontinental cultural milieu of the age.

European artists flocked to the Islamic capitals, particularly to Istanbul, offering their talents to foreign embassies and Ottoman institutions alike, their expertise ranging from military sciences and engineering to music and architecture. Many, most notably the French and

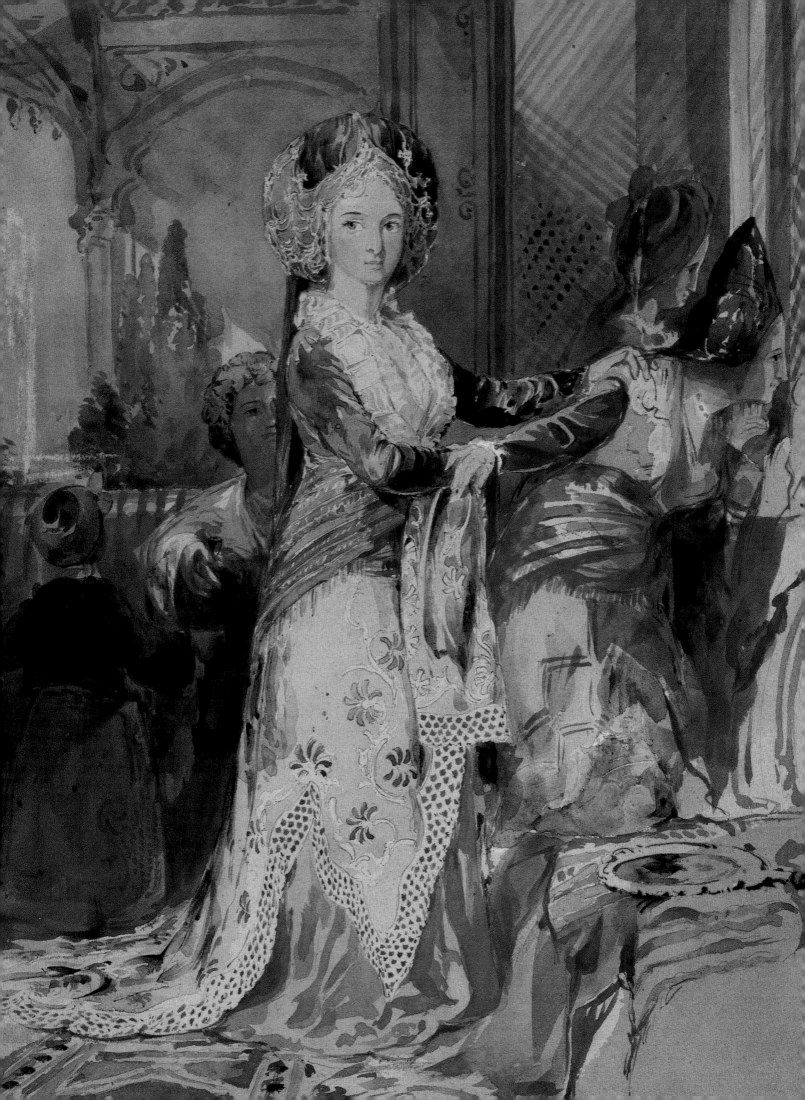

Ancient sites and antiquities from Roman, Hellenistic, and earlier civilizations attracted European travelers to the Ottoman Empire. Whether prompted by antiquarian taste or romantic interest in biblical times, artists sought out the ruins of vanished cities. As the nineteenth century progressed, Europeans gained greater access to important sites, from western Turkey to Lebanon and the Syrian desert. *(Pls. 10, 11, 12, 13)*

to some extent the Germans, were employed by the Ottomans to teach local students, while talented Turks were sent to European capitals to continue their education, later to return home and train the next generations.

To comprehend fully the complex cultural and social conditions that prevailed in the nineteenth century, one has to explore the political developments of the age as well as the advent of the phenomena known as Orientalism and Occidentalism.

HISTORICAL SETTING

The Ottoman Empire had evolved from a small Turkish principality established in the northwestern corner of Anatolia around 1300 and expanded its frontiers from the Caspian Sea to the outskirts of Vienna and from Podolia (in Poland) to the Sahara. For centuries, it was the most powerful state, controlling western Asia, eastern Europe, and northern Africa. In the course of this expansion, Ottoman sultans had also become the caliphs of Islam.

When territorial losses to European powers, particularly to the French and British, led to the waning of the Ottoman Empire's political and economic superiority, the state had no choice but to initiate a series of reforms. Military setbacks started with Napoleon's invasion of Egypt in 1798 and continued through the nineteenth century. Long wars with the Russians led to the loss of the Crimea in the 1850s; the French annexed Algeria in 1830 and Tunisia in 1881; and the British took Cyprus in 1878 and Egypt in 1882.

The Ottomans, who historically held a condescending attitude toward Europeans, realized that survival depended on military and administrative changes and that there were lessons to be learned from European technology. The process of Europeanization, initiated by Abdülhamid I (r. 1774-89) and continued under his successor Selim III (r. 1789-1807), began with military reorganization and the establishment of technical schools. Scores of Europeans, mostly French, were employed to set up educational institutions based on European academic systems to train future officers.

PLATE 10
A Lycian Tomb
John Peter Gandy RA
(1787-1850)
c. 1813
Pencil and watercolor
14.1 x 25.3 cm

OPPOSITE, TOP: PLATE 11
Ruins of the Temple of Artemis in Sardis
Clarkson Frederick Stanfield RA (1793-1867)
c. 1835
Pencil, watercolor, and gouache, heightened with white
23.3 x 35.5 cm

OPPOSITE, BOTTOM: PLATE 12
Temple of Bacchus at Baalbek
William Edward Dighton (1822-1853)
c. 1852
Pencil and watercolor
35.5 x 52.5 cm

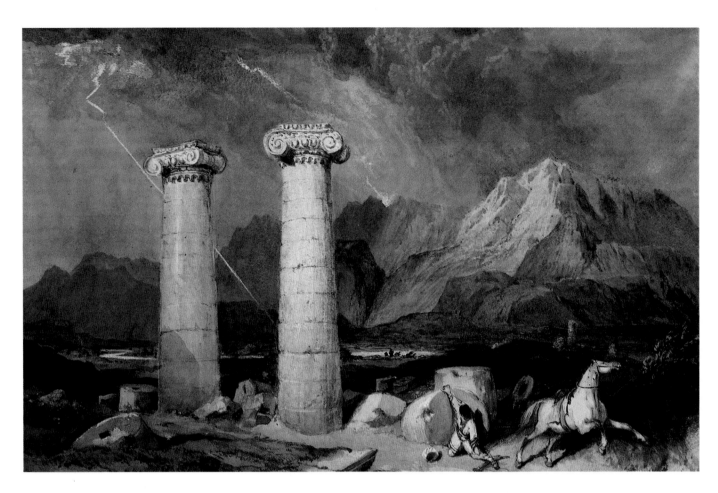

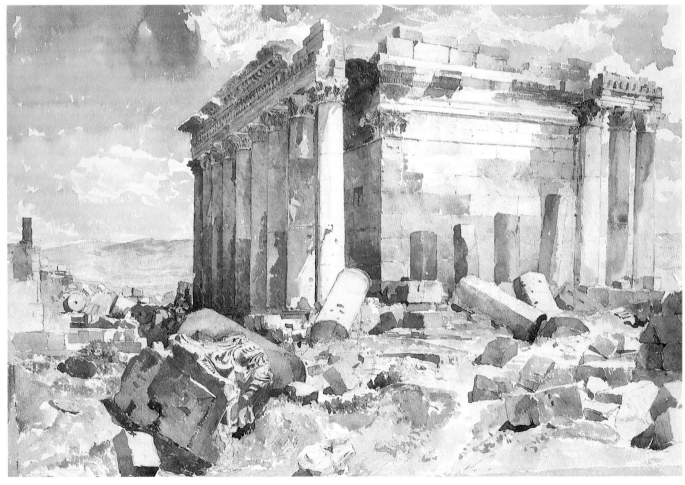

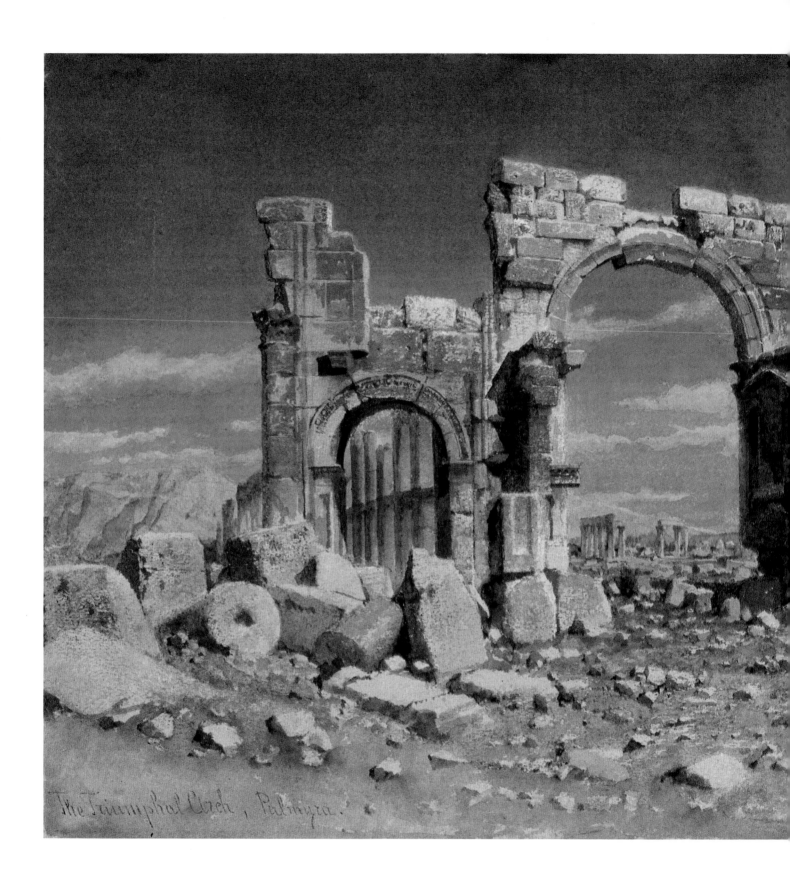

The Triumphal Arch, Palmyra.

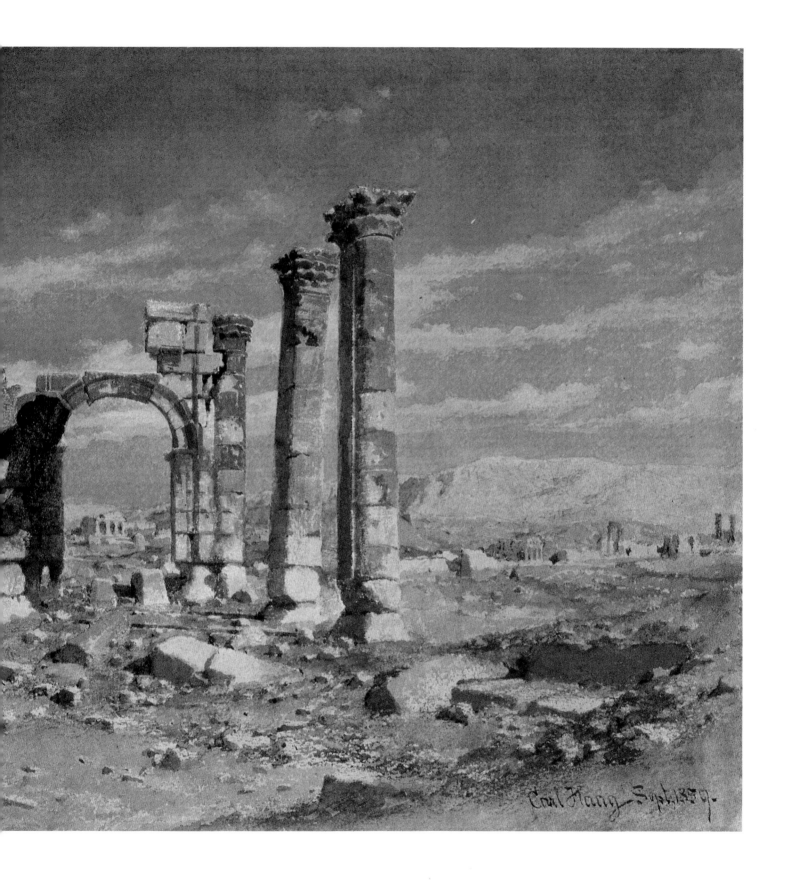

PLATE 13
Triumphal Arch in Palmyra
Carl Haag RWS (1820-1915)
1859
Watercolor
30.0 x 60.5 cm

The Ottoman Navy dockyards and administrative buildings, constructed on the shore of the Golden Horn in the early nineteenth century, reflect the influence of European neoclassic architecture.

PLATE 14
Naval Buildings and Dockyards on the Golden Horn
William Purser (c. 1790-c. 1852)
c. 1830
Pencil, watercolor, and gouache
30.4 x 42.8 cm

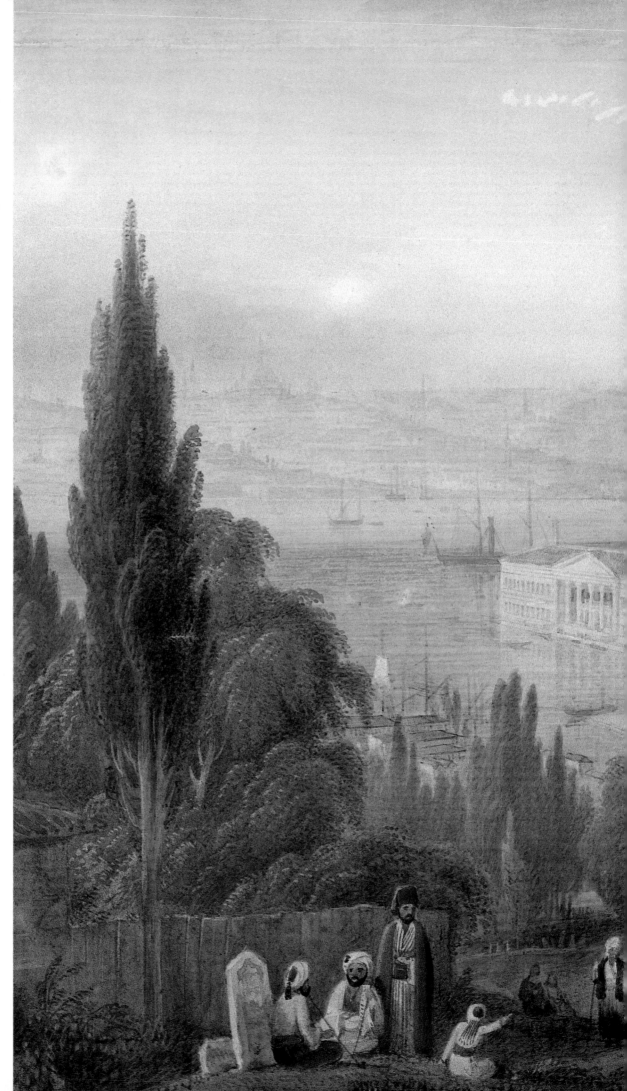

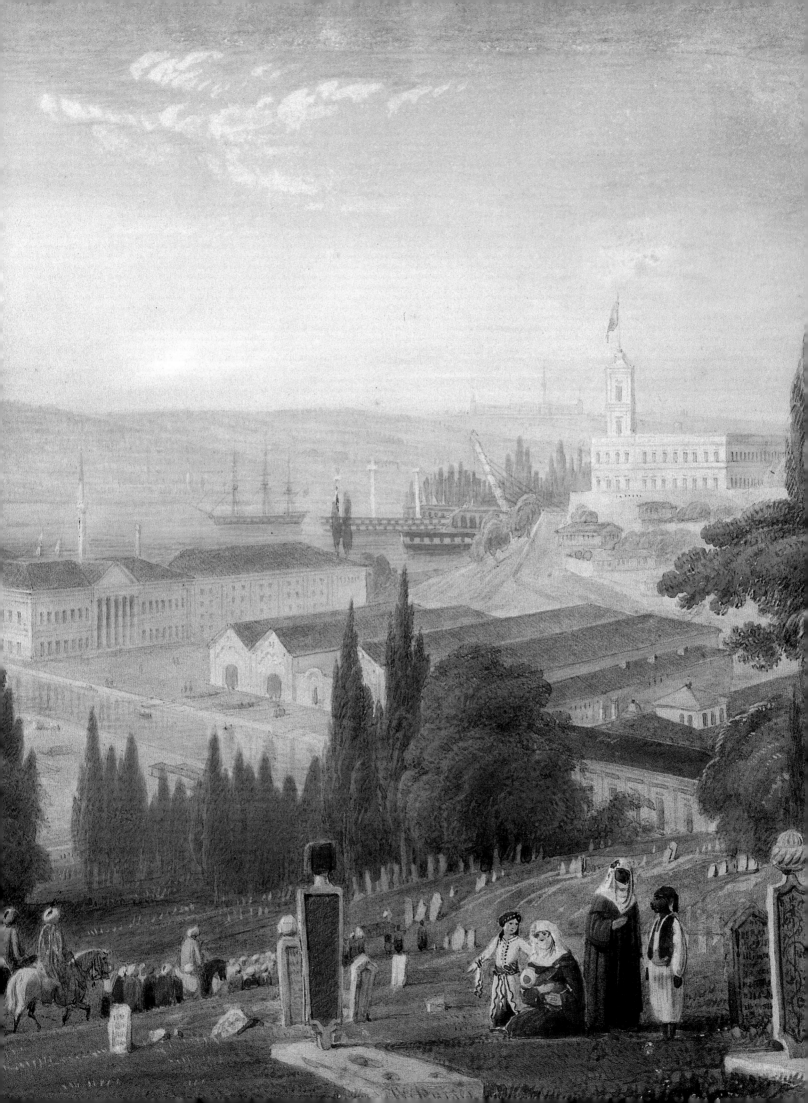

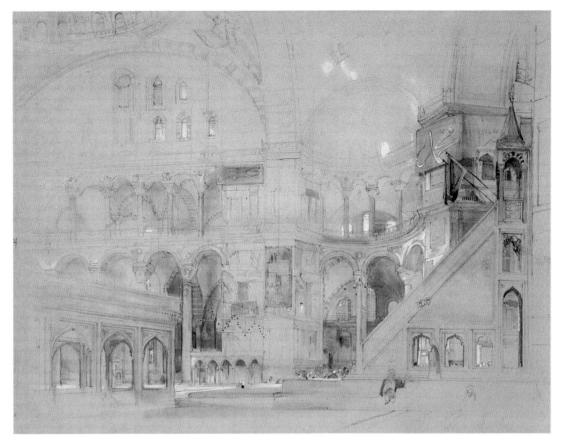

PLATE 15
Interior of Haghia Sophia, Istanbul
John Frederick Lewis RA
POWS (1805-1876)
c. 1840
Pencil, chalk, and watercolor, heightened with white
36.2 x 47.6 cm

•

Europeanization was fully endorsed by Mahmud II (r. 1808-39), who took further steps and abolished the traditional and troublesome Janissary Corps, the backbone of Ottoman might for centuries, replacing it with a new army whose officers were graduates of European-style academies. The Prussian officer Helmuth von Moltke was hired to teach; Italian composer Guiseppe Donizetti was assigned to work with the military band; American shipbuilder Henry Eckford came from New York to build frigates in Istanbul; and European academic curricula, textbooks, and instructors were used in all branches of military sciences, from engineering and architecture to medicine and music.

Mahmud II also initiated reforms in government administration: ministries of war, foreign affairs, interior, and treasury were established; long, flowing robes and voluminous headdresses were replaced by trousers, frocks, and the fez; and permanent embassies opened in all European capitals and in the United States. French became the language of new ideas and techniques, and the cultural traditions of France entered every elite Ottoman household.

Under Abdülmecid I (r. 1839-61), Mahmud II's successor, the process of Europeanization was fully in bloom. At the urging of the French-educated grand vezir, Reşid Paşa, a giant step toward secularization was attempted in 1839 with an imperial edict (Hatt-ı Şerif of Gülhane), which initiated the period known as the Tanzimat (the Ordering). Secular schools opened, based on French models with French instructors teaching humanities and sciences in their native tongues, followed by those established by the Germans, Italians, British, and Americans. Each school not only brought its own faculty and language, but also the peculiarities of its culture.

The Tanzimat was not without critics. Turkish journalists were the most articulate, and a group calling itself the New Ottomans

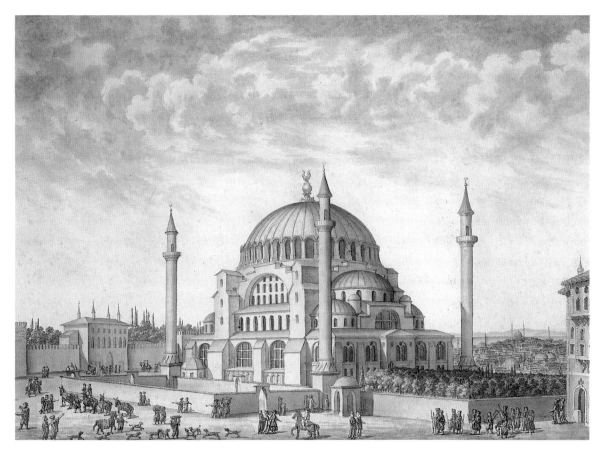

(Yeni Osmanlılar) opposed the absolute authority of the sultan and demanded a parliament and secular constitution. Forcing Abdülaziz (r. 1861-76) to abdicate in favor of his nephew Abdülhamid II (r. 1876-1909), they succeeded in creating a parliament with an elected body of deputies. This endeavor, however, was short-lived. Abolished by the sultan in 1878, it was not revived for another thirty years.

Abdülhamid II, an autocratic ruler, was nevertheless progressive in certain other areas. Communications within the empire improved with the inauguration of a telegraph system and the opening of the Baghdad and Hijaz railways, the latter running from Damascus to Medina.

The next opposition to political and intellectual repression came from a group known as the Young Turks, whose efforts brought about the restoration of the constitution. Elections were held, and the new parliament met in 1908. For the first time in Ottoman history, an elected body dismissed the sultan. The last descendants of the Ottoman house were to rule in name alone. Early twentieth-century events and the consequences of World War I resulted in the collapse of the Ottoman Empire and the rise of the Republic of Turkey. Founded in 1923, the Republic extended to Anatolia and parts of Thrace; its capital was moved from Istanbul to Ankara, thus severing a link to the past. Hence a modern state evolved whose history began with the pre-Islamic cultures of central Asia, progressed through centuries of Arabic-Iranian-Islamic traditions, and survived the nineteenth-century period of Europeanization.

EUROPEAN FASCINATION WITH THE OTTOMAN WORLD

The interest in the so-called Orient, an archaic word for Asia (also called the East, a Europocentric term), predates the Orientalist movement. European fascination with Asian cultures, generally resulting from military involvements, can be traced to the Greek and Roman periods and con-

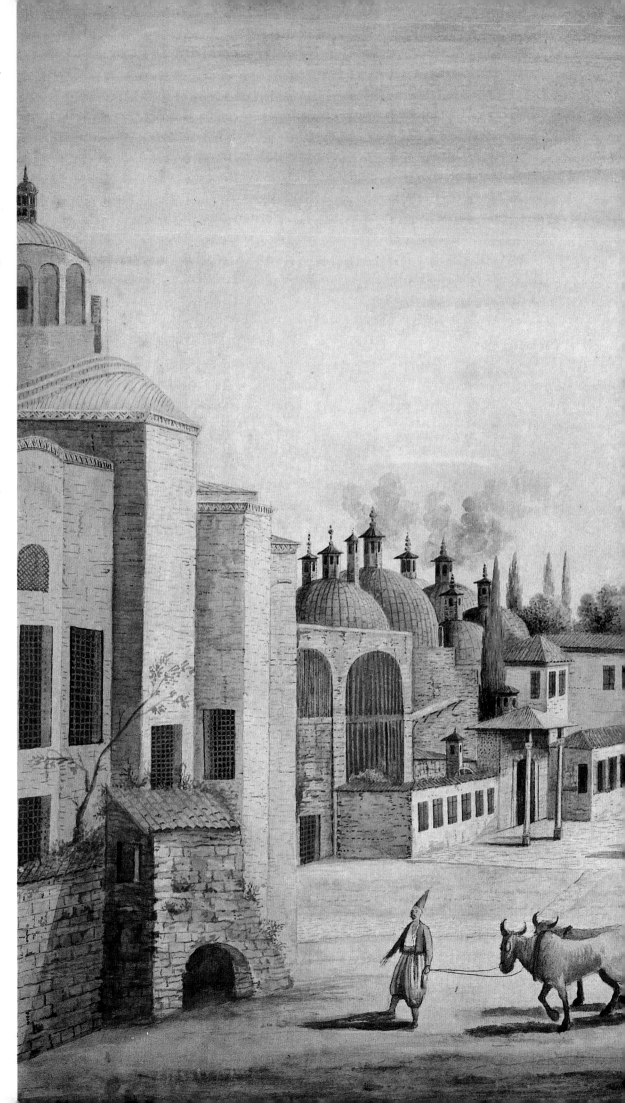

Mahmud II, a progressive sultan who ruled from 1809 to 1839, consulted leading European and American professionals in matters of education, military training, diplomacy, and finance. During his thirty-year reign, the elaborate robes and voluminous headdresses of court life began to be replaced by trousers, frock coats, and the fez. *(Pls. 17, 18, 19)*

PLATE 17
First Courtyard of the Topkapı Palace, Istanbul
Anonymous
Early 19th century
Watercolor and gouache, on laid paper
44.9 x 58.4 cm

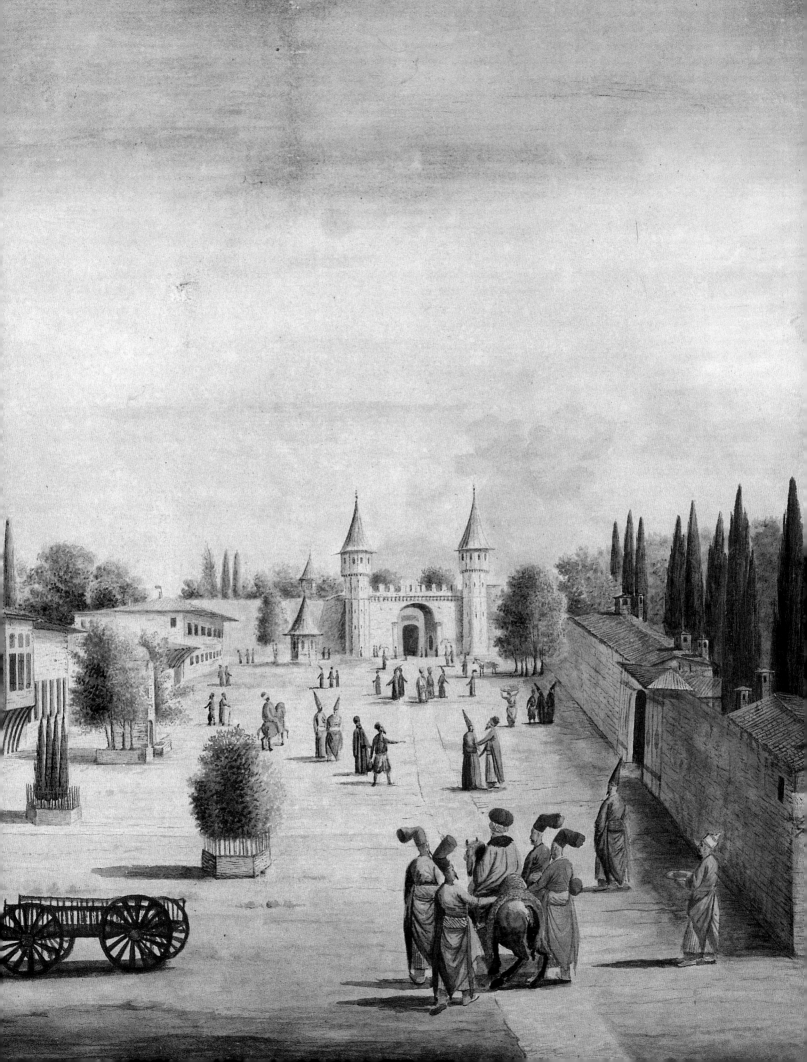

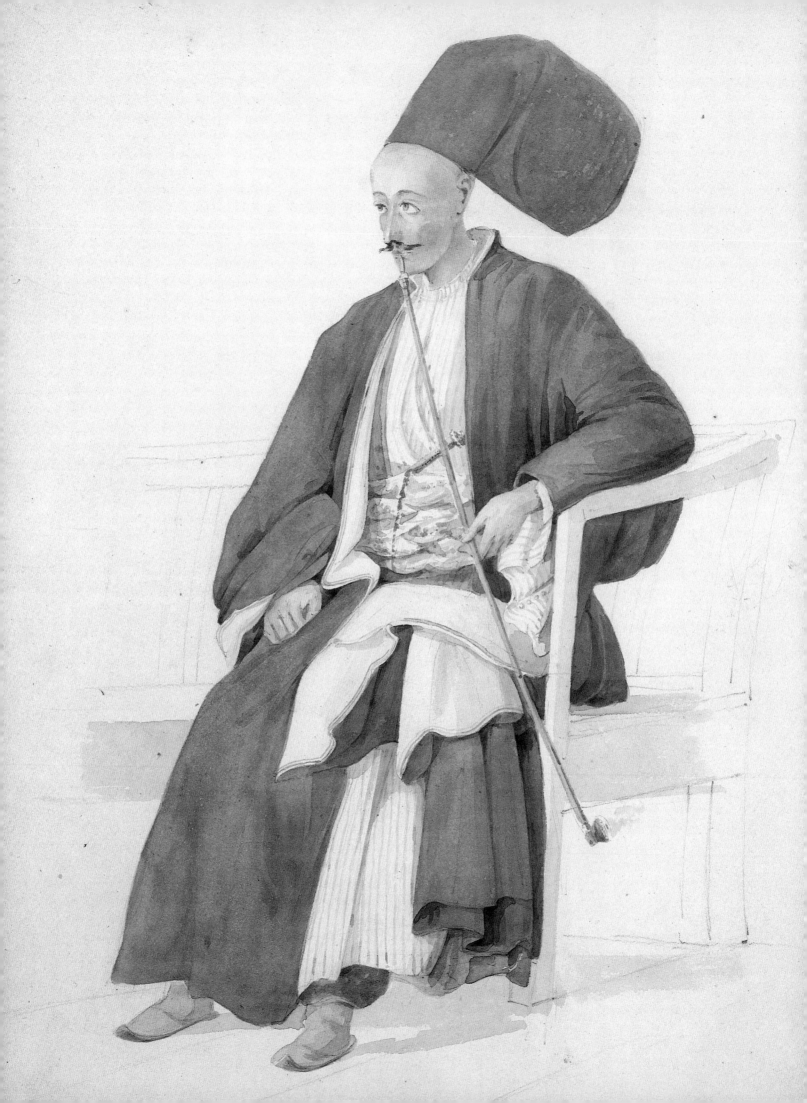

OPPOSITE: PLATE 18
A Bostancı, High-Ranking Attendant at the Sultan's Court, Istanbul
William Page (1794-1872)
c. 1817
Pencil and watercolor
35.2 x 23.8 cm

PLATE 19
Mehmed Agha Salam
Attributed to Louis Dupré (1789-1837)
c. 1820
Pencil and watercolor
32.0 x 24.8 cm

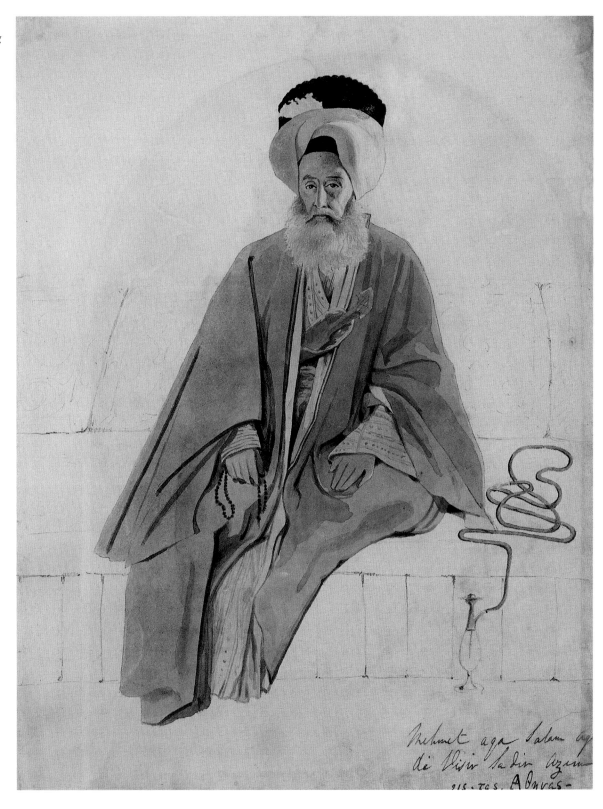

tinued through the Middle Ages, stimulated by the Crusaders. It became particularly intense during the Renaissance, especially after the Ottomans rose to power, conquered Istanbul in 1453, and made it the new capital of the empire.

Diverse foreign missions intent on procuring political and commercial concessions began to flood the Ottoman capital. Travelers, from pilgrims and merchants to adventurers and diplomats, recorded their experiences, some writing memoirs, others making sketches or hiring professional artists to produce renderings. Ottoman luxury goods were traded throughout Europe, and Ottoman exotica came into vogue, leading to the fashion known as the Turquerie. Turbaned figures in robes began to represent exotic rulers and merchants, awesome infidels, and legendary heroes. Some of the images—whether of elements of architecture, landscape, or costume as seen in murals, easel paintings, drawings, and prints—were fanciful, while other illustrations were based on firsthand experiences of European artists who traveled or resided in the region.

During the eighteenth century, a primary interest of European missions was to obtain topographic surveys of the Ottoman realms and to record the military activities of the Ottoman state. Although this was the objective, many artists became enchanted by the sites they visited, peoples they met, and ceremonies they attended.

In the nineteenth century, interest in the Ottoman world reached a peak, stimulated by increased political and commercial links, military and archaeological expeditions, improved means of travel, and reaction to the Industrial Revolution in which European romantics sought simple and basic values and such illusions as man in harmony with nature, set against the timelessness of a past civilization, albeit in ruins.

The resultant popularity of illustrated books on the Ottoman Empire prompted self-employed British artists to travel to western Asia to accumulate new material for the ever-growing demand for exotic scenes. Among these entrepreneurs were William Bartlett (pls. 5, 50, 51) and Thomas Allom (pls. 9, 20, 21, 22, 55), who worked in Turkey and other regions of the Ottoman world in the 1830s and 1840s. Bartlett, a prolific landscape artist renowned for his panoramic views, produced over one thousand images based on his five trips to western Asia. His studio in Pera, the district in Istanbul where foreigners resided, became a gathering place for foreign and native artists. Allom, who first worked for the French and later became one of the founders of the Institute of British Architects, also traveled extensively, and even ventured to China.

Other nineteenth-century artists were employed by schools of western Asian studies and participated in archaeological expeditions. French and British experts and artists were the first to exploit their talents, followed by the Germans, other Europeans, and Americans. These expeditions contributed to scholarship of ancient civilizations and enriched national museums in London, Paris, and Berlin, which acquired not only unique works of art but also the remains of entire sites and cities. Large-scale vandalism of ancient sites and pilfering of works of art were undoubtedly the worst disasters caused by the growing interest in western Asian scholarship. In the 1880s, the Ottomans established antiquities laws to fight clandestine excavations and illegal art traffic, and other nations in the region followed suit.

Trained as an architect, Thomas Allom became a prolific draftsman of Ottoman scenes, traveling from Istanbul to such other cities as Bursa, one of the earlier Ottoman capitals. His works were extensively reproduced as engravings in European travel books. (Pls. 20, 21, 22)

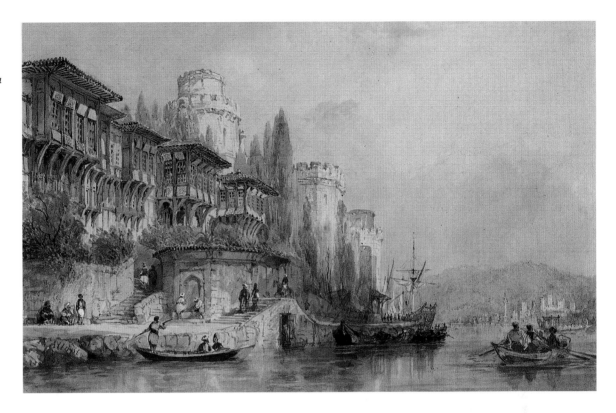

PLATE 20
*Summer Pavilions and
Rumeli Hisarı on the
Bosphorus, with Anadolu
Hisarı in the Distance*
Thomas Allom FRIBA
(1804-1872)
1846
Pencil and watercolor,
heightened with white
19.4 x 30.7 cm

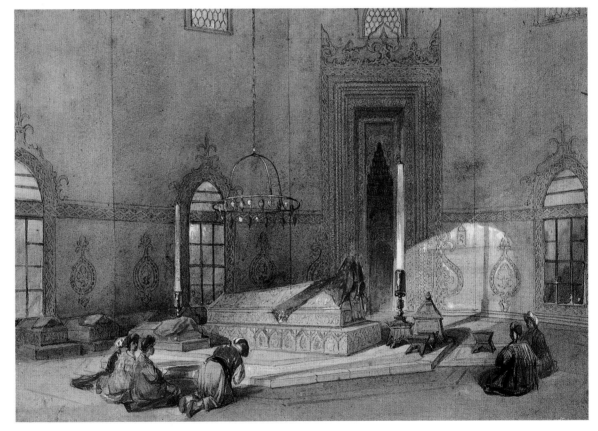

PLATE 21
*Mausoleum of Sultan
Mehmed I in Bursa*
Thomas Allom FRIBA
(1804-1872)
c. 1838
Pencil and watercolor,
heightened with white
21.2 x 30.0 cm

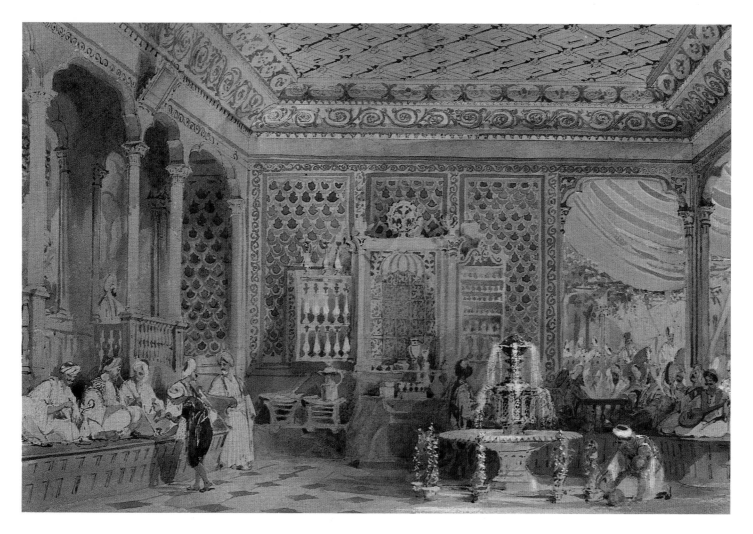

OTTOMAN FASCINATION WITH EUROPE

Life in nineteenth-century Istanbul offered the best of both worlds. Old Istanbul, located west of the Golden Horn, was still traditionally Ottoman, with its numerous domes and minarets silhouetted against the sky, endless maze of bazaars bustling with activity and selling all imaginable kinds of goods, and the fearsome bureaucracy of the Sublime Porte (the grand vezir's headquarters). New Istanbul, with its Pera district across the Golden Horn, was similar to any other European city, with hotels, banks, theaters, commercial offices, embassies, and multiethnic residents. Reforms undertaken by the state concerning military, educational, and administrative institutions—and even clothing—were changing the lifestyle of the capital and its physical appearance. Istanbul was undergoing the process of urban development (similar to Paris, Vienna, Rome, and other flourishing capitals); while members of art circles, promoted by the court and enlightened urban residents, enjoyed continual contact with foreign artists and their traditions.

As mentioned earlier, a central target of Ottoman reforms was the military, with architects and engineers recruited from Europe to assist in the transformation. In 1801 the Imperial College of Military Engineering (Mühendishane-i Berr-i Hümayun) was established; opening in 1882 was the School of Fine Arts (Mekteb-i Sanayi-i Nefise), modeled after the French Ecole Nationale des Beaux-Arts, which was followed in 1884 by the School of Civil Engineering (Hendese-i Mülkiye Mektebi), an extension of the Imperial College of Military Engineering based on German institutions.

PLATE 22
Coffee House, Istanbul
Thomas Allom FRIBA
(1804-1872)
1838
Pencil and watercolor, heightened with white
20.3 x 30.2 cm

40

Istanbul began to lose its Ottoman flavor and resemble a European city, with the French and Germans competing for superiority in educational systems and, more pronouncedly, in architecture. The German architect A. Jachmund, who was sent to Istanbul by his government to study Ottoman architecture, became an instructor at the School of Civil Engineering and was assigned to build the famous Sirkeci Railroad Terminal (1890). This was the last European stop on the Oriental Express in Istanbul before passengers were ferried across the Bosphorus to Haydarpaşa on the Asian shore of the capital to resume their trip. At Haydarpaşa they entered a Bavarian-style terminal, built by Otto Ritter and Helmuth Cuno (1908). Both the Sirkeci and Haydarpaşa terminals are perfect examples of nineteenth-century eclecticism, combining misunderstood Islamic and Ottoman features with bold Germanic aesthetics.

French architects working in Istanbul produced similar incongruous configurations. Alexandre Vallaury, chief instructor at the School of Fine Arts, designed the highly ornate Ottoman Bank in the neoclassical style, while his building for the Ottoman Public Debt Administration (1899) included such pseudo-Islamic elements as cantilevered eaves, pointed arches, turned wood grilles, tiled interiors, and a peculiar dome with small rounded windows (traditionally employed in Ottoman baths) placed over the entrance hall.

The Royal Museum of Antiquities (Asar-ı Antika Müze-i Hümayun), the first archaeological museum in Istanbul (1891-1907) and still functioning as such, is another Vallaury building. Following the neoclassical style adopted by almost all nineteenth-century museums around the world, the Royal Museum's decorative elements display Greco-Roman aspirations, possibly in an attempt to reflect the cultures displayed inside. This heavy and somber building, situated on the Topkapı Palace grounds, forms a contrast to earlier structures of the complex, which are visually lighter, delicate, and charmingly detailed.

Foreign architects working in Istanbul changed the appearance of the capital and, through their academic posts, indoctrinated young architects with their own aesthetics. Even the Sublime Porte (Bab-ı Ali) became a neoclassical complex, created in 1843 by the Fossati brothers, Italian-educated Swiss architects who designed the Dutch and Russian embassies in Istanbul.

A natural course of events followed. Although European-trained, Turkish architects soon developed their own design vocabulary, which was far more in tune with their cultural traditions. Two figures exemplify this development. One, Vedat Tek, went to Paris to study painting, switched to civil engineering, and ended up becoming an architect. The first Turk to teach architectural history at the School of Fine Arts, his works successfully combined Beaux-Arts styles with traditional Ottoman elements, as observed in the Central Post Office and the Imperial Offices of Land Registry, both built in 1909 in Old Istanbul.

Kemaleddin Bey, who started in Istanbul with Jachmund and went to Berlin to further his education, was the second figure. Appointed in 1900 as chief architect of the Ministry of Pious Foundations and responsible for preserving all endowed monuments within the empire, he became an expert on Ottoman architectural techniques and styles, restoring many historical buildings and designing new edifices. His mosques are perfectly attuned to traditional rituals while displaying a personal style; and his housing complex designed for the low-income families who were displaced by a disastrous fire was a major architectural achieve-

Istanbul's elite gathered at this site on the Asian shore of the Bosphorus, located several kilometers north of the old city. Ottoman fortifications, Rumeli Hisarı (Fortress of Europe) and Anadolu Hisarı (Fortress of Anatolia), poised opposite one another at the narrowest point of the Bosphorus, fill the left and right middleground of Purser's watercolor. See pl. 20 for a closer view of the fortifications.

PLATE 23
Meadow at the Sweet Waters of Asia on the Bosphorus
William Purser (c. 1790-c. 1852)
c. 1830
Pencil, watercolor, and gouache
30.3 x 45.1 cm

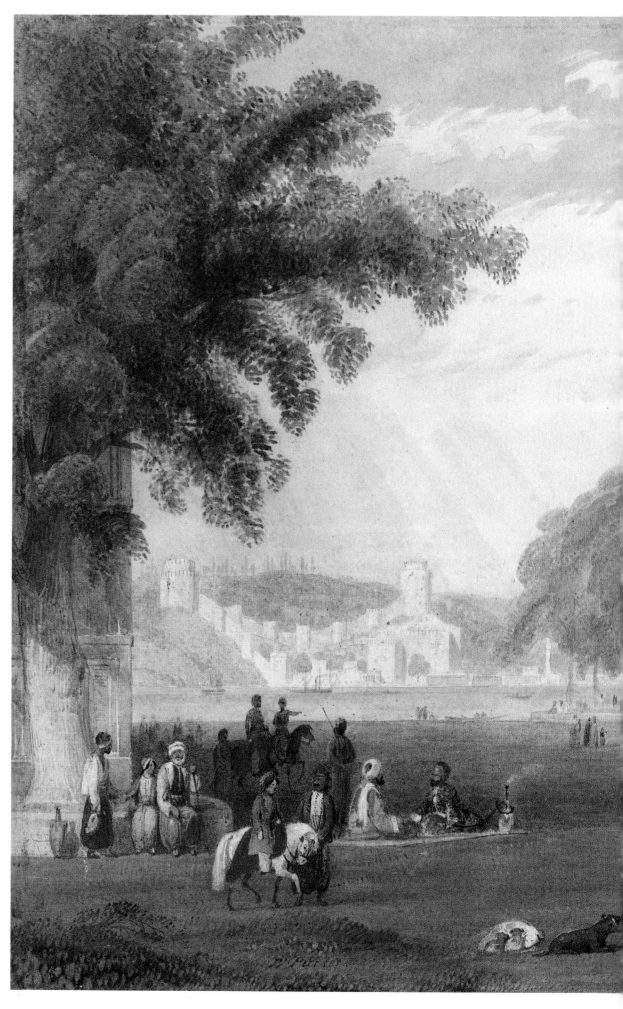

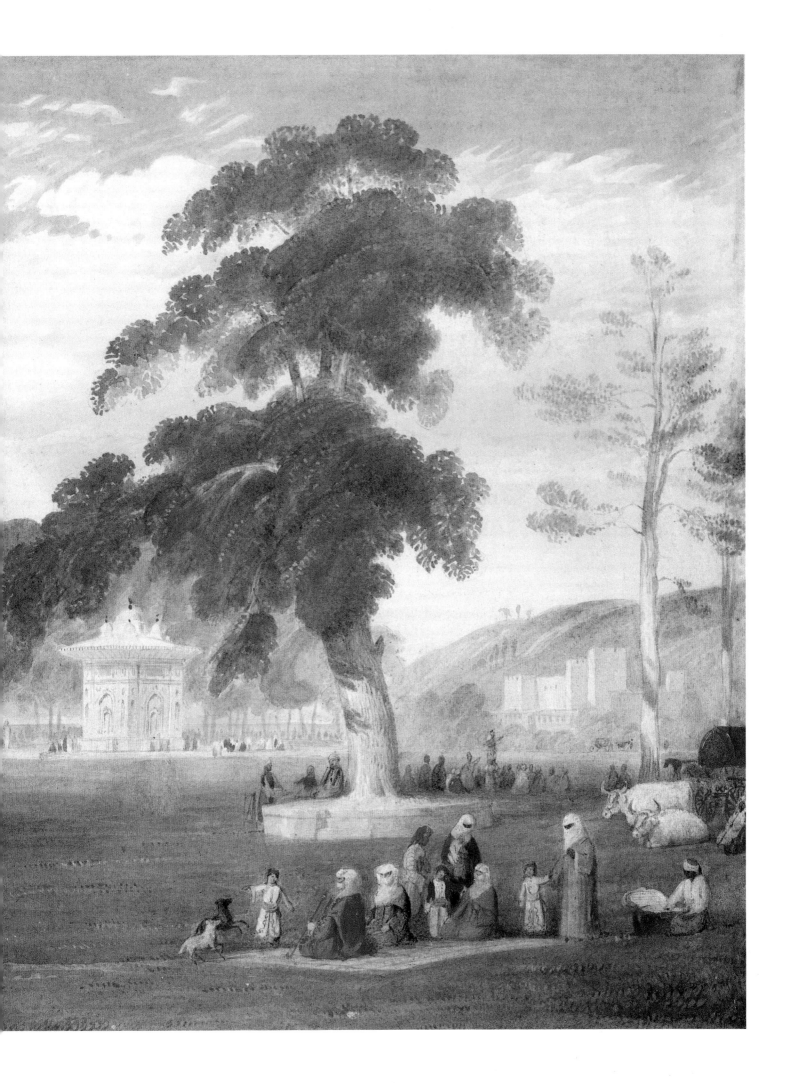

ment that responded to public needs. The latter, called the Harikzedegan (Fire Victims) Apartments, had 124 units in four six-story blocks; each block was centered around a courtyard, providing both private and communal areas. Now restored and converted into a hotel, the complex still functions admirably.

Introduction to European styles of painting began during the first quarter of the eighteenth century but was limited to decorative themes and details. Until then, Ottoman painting was essentially a decorative art employed to illustrate books and, to a lesser extent, to embellish walls. In the mid-sixteenth century, when historical texts were first illustrated in the court, artists started to represent contemporary events with realistic details, their depictions of settings and personages based on personal observations. Biographies of the sultans were popular, with attention given to imperial ceremonies, court activities, and, in particular, conquests of foreign cities. The last theme not only documented regions and fortresses conquered by the Ottomans but also promoted a genre of topographic painting with military overtones that was not far removed from the works of early European Orientalists.

Manuscript illustrations ceased to be in demand after the mid-eighteenth century, when they were gradually replaced by detached paintings and murals. Landscapes with panoramic views of the capital adorned the walls of secular and religious buildings; and single paintings, either compiled into albums or framed and hung on walls, represented diverse figure types and festive activities.

It is interesting to compare the works of eighteenth-century European Orientalists with those of contemporary Ottoman artists who depicted scenes of women washing in bathhouses or men drinking in taverns, as well as panoramic renditions of Istanbul or other major cities. Although employing regional styles and techniques, they display a number of similarities in subject matter and approach.

The impact of European themes and techniques on Ottoman art accelerated under the Tanzimat, when court members started to collect easel paintings and attend art exhibitions. Many artists from France, England, Austria, Sweden, Germany, Italy, Belgium, and Malta came to Istanbul, including the German Carl Haag (pl. 13), Britons John Frederick Lewis and Edward Lear (pls. 4, 15, 47, 82), and Amadeo Preziosi from Malta (pls. 8, 25, 60, 61). Preziosi became court painter to Abdülhamid II, together with the Italian artist Fausto Zonaro, who first worked in Venice and after 1891 in Istanbul. Preziosi died in Istanbul in 1882 and was buried in San Stefano Catholic Cemetery.

In the early nineteenth century, Mahmud II sent one of his artists, Rupen Manas, to be trained in Paris and later directed that portraits painted by Manas be hung at the Sublime Porte. Abdülaziz, himself an artist, took his court painter with him to Egypt in 1863. In 1867, the sultan traveled to Europe, the first Ottoman monarch to do so, where he visited the Paris International Exhibition. In Vienna he saw the paintings at the Belvedere Palace. With the assistance of two Turkish artists then studying in Paris—Osman Hamdi and Şeker Ahmed Paşa—he purchased paintings by such masters as Jean-Léon Gérôme, Gustave Boulanger, and Charles-François Daubigny for the palace. The sultan also had several European painters working for him in Istanbul, including the Frenchman Pierre Désiré Guillemet, who later set up a private academy of painting.

The first painting exhibition in Istanbul, held in 1873, included works by both Turkish and European painters. The exhibition attracted great attention, and its opening was attended by high officials, among

Whatever their national or religious backgrounds, women found that their public excursions in nineteenth-century Istanbul were controlled by strict rules of dress and decorum, while the privacy of home permitted greater freedom. (Pls. 24, 25, 26)

OPPOSITE: PLATE 24
Armenian Woman, Istanbul
William Page (1794-1872)
c. 1823
Pencil and watercolor, heightened with applied gold paint
37.3 x 26.3 cm

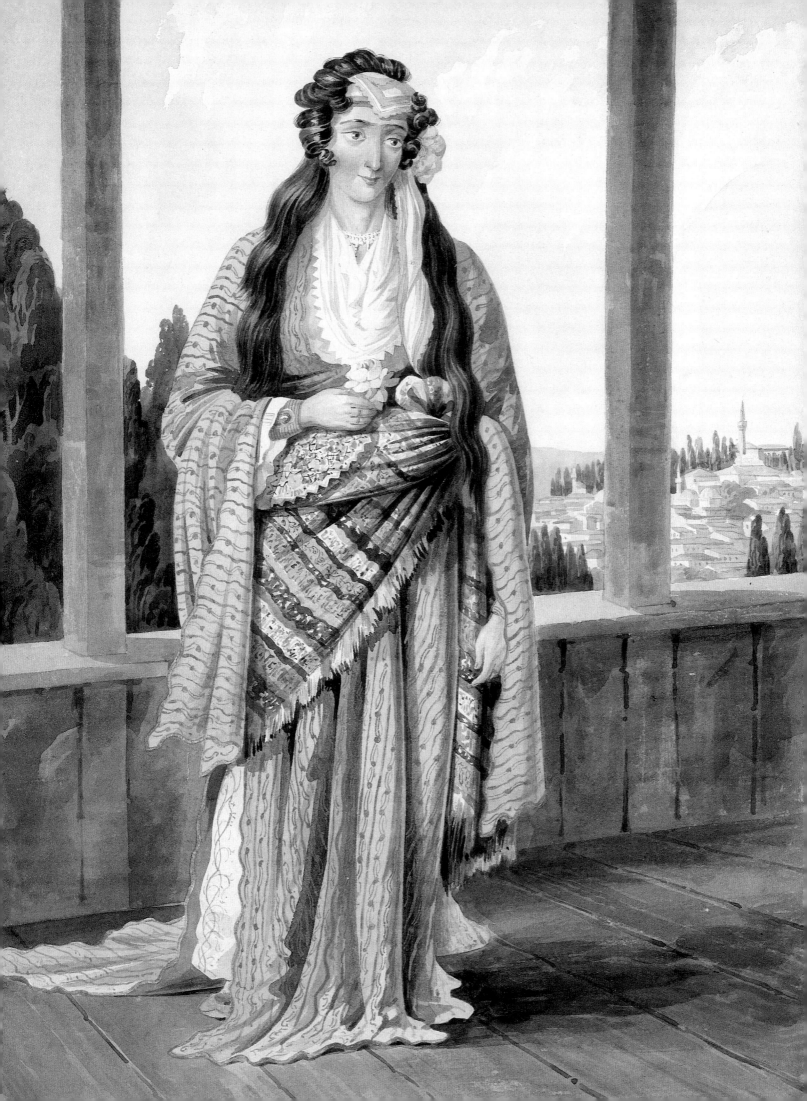

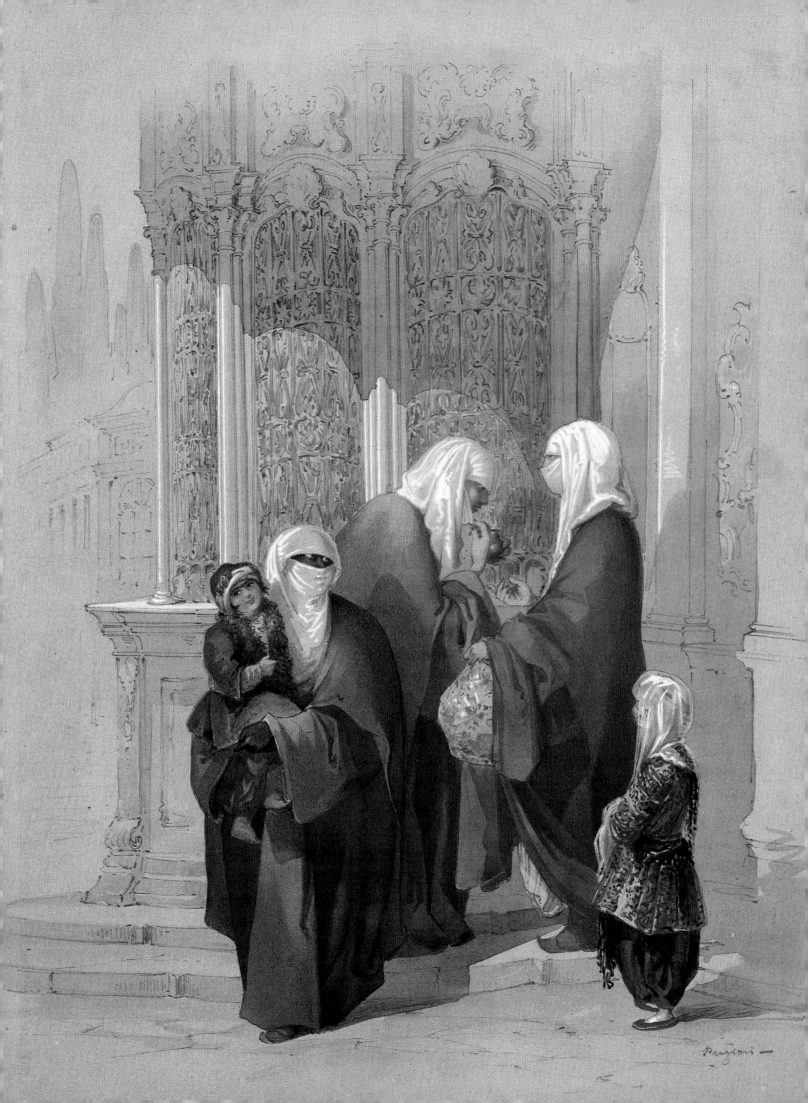

OPPOSITE: PLATE 25
*Women at a Street
Fountain*
Amadeo, Fifth Count
Preziosi (1816-1882)
c. 1845
Pencil and watercolor,
heightened with white
28.9 x 22.2 cm

PLATE 26
Jewish Woman, Istanbul
Anonymous
19th century
Pencil, watercolor, and
gouache, on green paper
27.5 x 19.4 cm

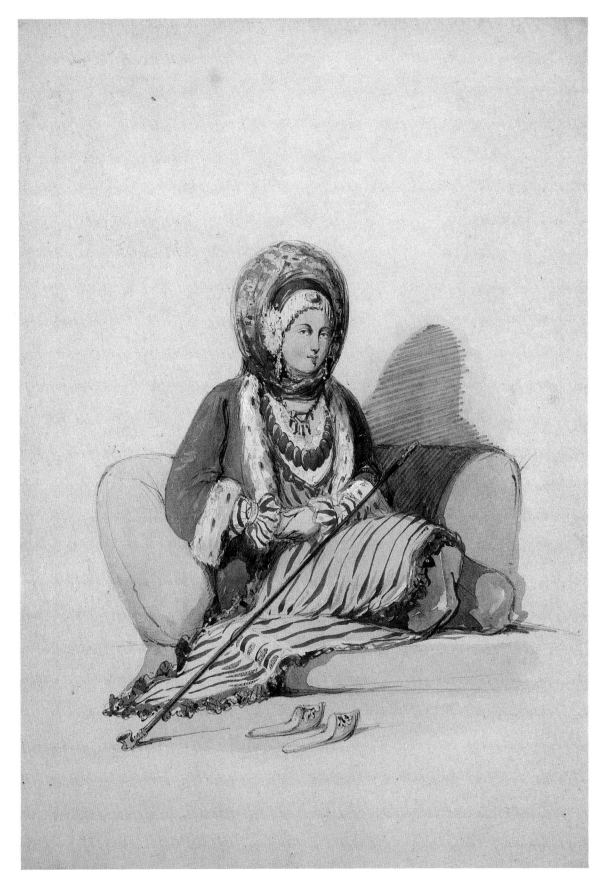

them the crown prince and the entire diplomatic corps. A second exhibition, held in 1875 at the newly founded University of Istanbul, once again combined the works of Turkish and European artists. These activities were enormously successful in awakening public interest in the arts and creating a market for oil paintings. Escalating public interest was one reason for the opening of the School of Fine Arts under the direction of the Ministry of Education. Private training was also available to both men and women at the Guillemet Academy of Design and Painting in Istanbul.

In addition to the increasing availability of formal art education, salons started to appear in Istanbul. Initiated by Vallaury and Régis Delbeuf, the editor of the local newspaper *Le Stamboul*, the first Istanbul salon opened in 1901 in the Pera district at the residence of a French merchant. On display were paintings by Turkish artists, Levantines (Europeans living in the Levant, that is, western Asia), Europeans, and instructors at the School of Fine Arts. The popularity of this attempt led to the opening of other salons that were larger in scope, displaying engravings, architectural projects, and handicrafts, but the majority of works were oil paintings depicting landscapes, cityscapes, interiors, portraits, and picturesque vignettes in the true Orientalist genre. Works by Turkish artists were virtually indistinguishable from their European counterparts, demonstrating the same techniques, themes, and—more significantly— the same romantic approach to sites, settings, and figure types.

The engineers, architects, and physicians in the new Ottoman military academies were expected to be proficient in making surveys and maps, technical drawings and prints, and topographic and anatomical renderings. Europeans were hired to teach these skills in academies, and promising students were sent to Europe to further their education. Upon returning, they entered the academic field as teachers, became commissioned officers, or held high government posts. A number, however, became professional painters. Technical studies, including drawing and painting, were also offered in non-military schools that trained civilians.

A survey of the lives and works of three nineteenth-century individuals exemplifies the diversity of educational backgrounds of the Turkish artists who bridged cultural traditions and laid the foundation of intercontinentalism: the first was an independent artist who became an archaeologist, museum administrator, and educator; the second was a distinguished member of the military academy; and the third was an Ottoman crown prince and the last caliph of Islam. Each was a product of his times, combining European and Turkish traditions to create works of art that were not only individualistic but also unique to their own culture.

The first artist, Osman Hamdi (1841-1910), a native of Istanbul, was sent to Paris by his family at the age of fifteen to study law. He lived in Paris for twelve years and studied at the Ecole des Beaux-Arts with Boulanger and Gérôme, two of the greatest French Orientalists. Renowned for his figure paintings, Hamdi at times made use of the newly invented camera: he would pose his models in theatrical settings, photograph the scene, and then execute one or more studies from the photographic images.

Hamdi's representations of esoteric figures, and ornate interiors and exteriors of traditional architecture were identical in approach to those of the French Orientalists, depicting both the timeless quality of man at peace with his environment and a concentration on spiritual values. Picturesque works, such as the *Arms Merchant* (fig. 2), with exotic figures and settings, polished details, and narrative imagery, could

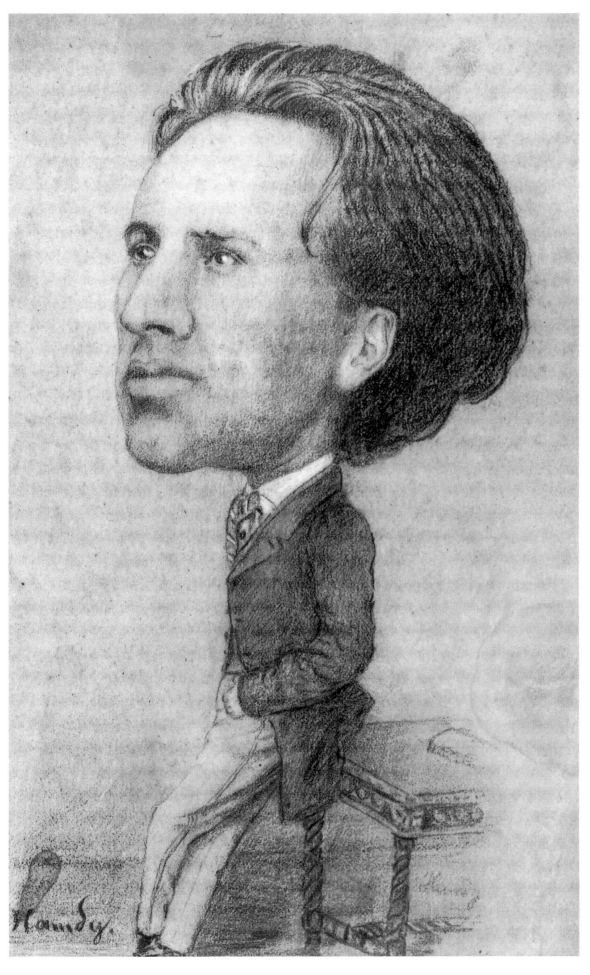

FIGURE 1
Osman Hamdi
Self-Portrait
c. 1860-70
Black and white chalk
on paper
24.0 x 14.2 cm
Private Collection

49

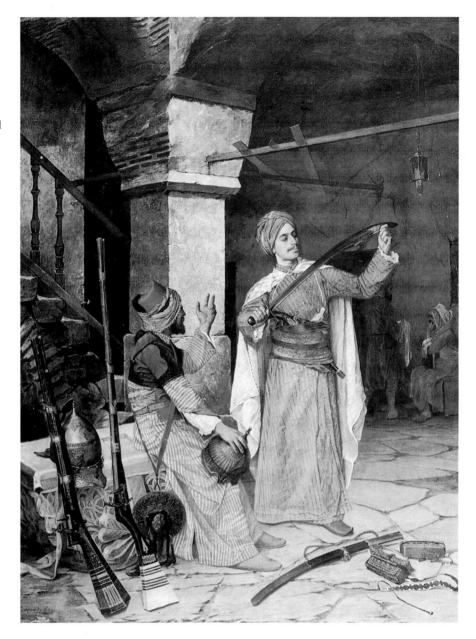

have been produced by any Beaux-Arts graduate. Hamdi also experimented with the new genre of caricature, either using himself as the subject (fig. 1) or depicting contemporary Turkish politicians in a witty yet profoundly critical manner.

Upon returning to Istanbul from Paris in 1868, Hamdi entered the Ottoman civil service in the external affairs department of the state. Appointed director of the new archaeological museum in 1881, he became deeply involved with establishing administrative guidelines, acquisition policies, and antiquities laws. The following year he was given the additional responsibility of the directorship of the School of Fine Arts, where he determined academic curricula and taught painting. It is remarkable that Hamdi also found time to excavate. Many prehistoric, Hittite, Hellenistic, and Roman sites were already being unearthed by European teams, and Hamdi undertook several excavations under the auspices of the archaeological museum, conducting digs in Anatolia as well as in Iraq and Syria. An exceptional artist and scholar, Hamdi was an Orientalist in every sense of the word.

It is interesting to note that Hamdi signed his works as "Hamdy,"

using the French practice of transliterating Ottoman Turkish, which was written with Arabic characters at the time. The Latin alphabet was adopted after the advent of the Republic, adding a number of diacritics and letters that are far more suitable for writing and pronouncing Turkish. Hamdi, unfortunately, did not live long enough to witness the language reform, with which he would have agreed even though it meant that he had to write his name with an "i" instead of "y" to conform with the new system of Turkish orthography.

Şeker Ahmed Paşa (1841-1906) represents those artists who were initially trained to become army officers (fig. 3). Upon graduating from the state military academy, he was sent by the state to Paris. For eight years Ahmed studied with Boulanger and Gérôme at the Ecole des Beaux-Arts and spent some time in Rome. He participated in several exhibitions, including the 1867 Paris International, which was visited by Abdülaziz. When he returned to Istanbul, Ahmed taught painting at the military academy's School of Medicine and at the School of Fine Arts. Specializing in landscapes, portraits, and still lifes, he was active in organizing painting exhibitions in Istanbul. He advanced in military rank

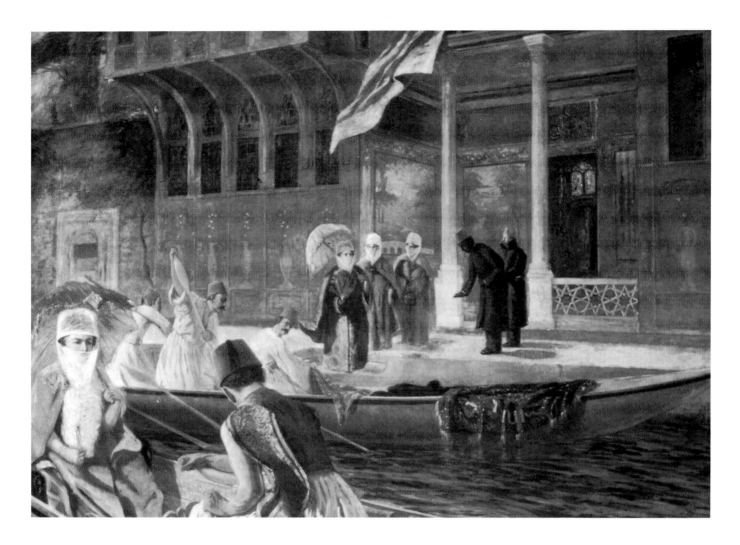

throughout his academic career, holding the prestigious post of Indendant of the Palace (Saray Nazırı) with the title of Paşa (commonly written in English as Pasha) at the time of his death.

Involvement with the arts, particularly poetry and music, was a passion with educated Ottomans and ardently supported by the ruling family, to which the third artist belonged. Growing up in an intellectual and supportive environment, many princes and princesses became accomplished artists. The Ottoman house traditionally encouraged practice of the arts, and since the foundation of the empire each sultan was obliged to have a tangible trade. Throughout the centuries the dynasty produced renowned poets and calligraphers. Selim III was an acclaimed composer, and Abdülhamid II was a talented woodcarver; Crown Prince Abdülmecid (1868-1944), son of Abdülaziz, distinguished himself as a painter. Although he did not study in Paris, his works were exhibited there. Concentrating on portraits, especially group portraits of his family, the prince depicted the activities of the Ottoman imperial family's last days. His subjects recline on chaise lounges, quietly reading Goethe or absorbed in their own thoughts. Veiled princesses board imperial barges for excursions on the Bosphorus (fig. 4), or a portrait of a favorite horse fills the canvas. One of the larger group portraits, entitled *Beethoven in the Palace*, shows the imperial family playing piano, violin, and cello with Beethoven's notes scattered on the floor, and the maestro's bust placed in the background. The prince himself, seated on the far right in military uniform, participates as an observer (fig. 5).

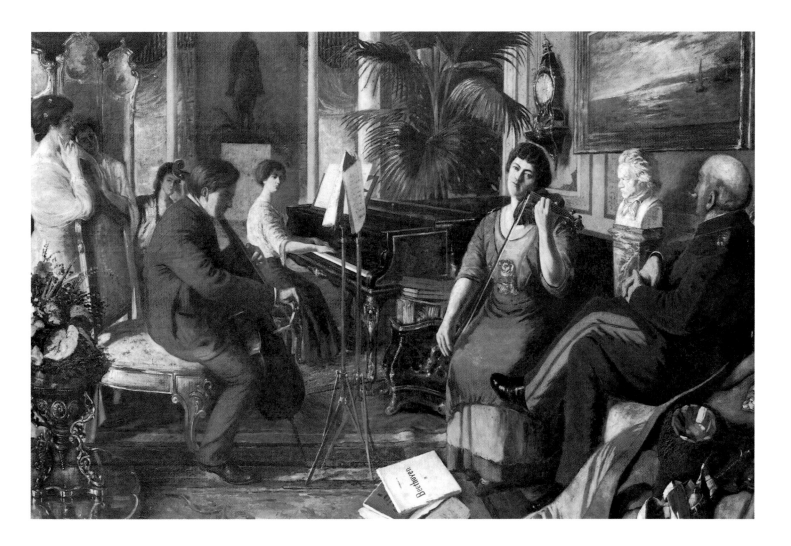

After the sultanate was abolished in 1922, Abdülmecid, the last heir of the Ottoman house, ruled only as caliph until that post was also abolished in 1924. He was exiled, together with the rest of his family, and died in Paris twenty years later.

CONCLUSION

As the Ottoman world absorbed the traditions of Europe and began to display intercontinental features, it ceased to be a source of fascination to Orientalists, whether of native or foreign origin. The excitement of discovering the exotic waned, as exemplified by the dismay of Empress Eugénie, wife of the French emperor Napoleon III (r. 1852-71), when she visited Istanbul in 1869 and saw that the Ottoman sultan was wearing outfits fashioned by a European designer. Orientalism as an art movement, and as an escape from the mundane and familiar, died by the turn of the twentieth century, when the traditional Ottoman way of life ceased to exist. Although bemoaned by romantics as having been killed by the influx of European influences and industrialization, this way of life was in reality a phase that the Ottoman Empire—and its arts—passed through in an effort to find its national identity. The great changes of the twentieth century and the proclamation of the Republic brought forth international artistic forms and styles in which individual modes of expression transcended geographic and cultural boundaries.

FIGURE 5
Crown Prince
Abdülmecid, *Beethoven in the Palace*, c. 1910
Oil on canvas
154.0 x 221.0 cm
Istanbul, Museum of Painting and Sculpture

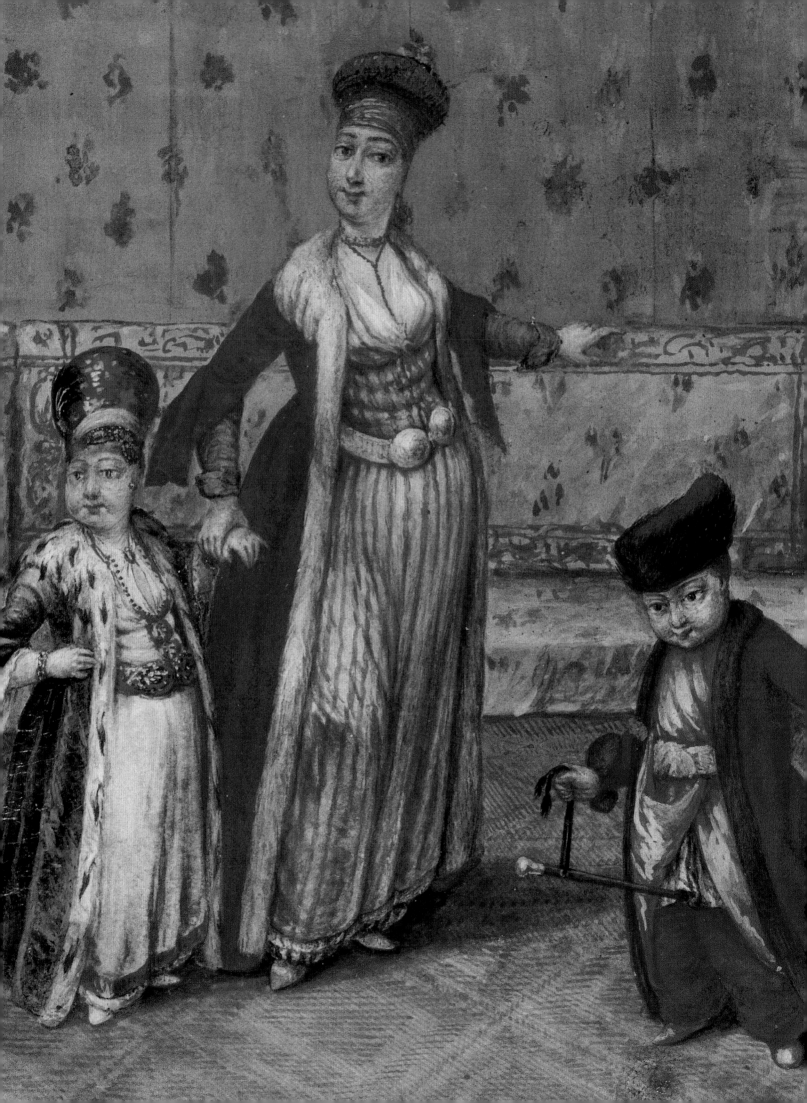

Middle East Observed

Sarah Searight

Sarah Searight, a Middle
East specialist and Islamic
art historian, is the author
of *The British in the Middle
East* and *Steaming East*.

The economic and political backgrounds to the watercolors and drawings of the Middle East in the Searight Collection reflect in a great many ways the connections of my father, Rodney Searight, with the region. He knew the area well, mainly from his employment from the 1930s by Shell Oil International, but also from wartime activities in British intelligence and from travels as a tourist. Many of the artists whose paintings he collected came to the area for similar reasons—commercial, political, and also pleasurable.

Early Contacts

The Middle East has exerted a powerful and enduring fascination over the West. Trade, diplomacy, and tourism kindled this attraction and helped to inspire the works of art in this exhibition—from minutely detailed drawings to studies of magnificent costumes and images of exotic landscapes.

First of all, to look at collections such as the Searight, one needs a sense of the degree to which commerce and trade generated intense artistic interest in the Middle East. Before the eighteenth century, contacts between Europe and the Middle East were largely dependent upon the commercial links that extended through time and were, in fact, responsible for Rodney Searight's own stay in the region, and the growth of his affection and artistic appreciation for it.

Trade between East and West through the Middle East can be traced back several millennia, but for our purpose the Crusades make a useful starting point. While their campaigns interrupted partially the regular trade, Crusaders returning home to Europe helped cultivate a taste for oriental specialties, such as textiles, ceramics, and spices. Invasions from Central Asia in the mid-thirteenth and early fifteenth centuries also interrupted trade, but in post-conquest periods the Mongol Empire provided the relative security in which trade could flourish. This trade—often in the hands of Venetian merchants such as Marco Polo and his family, and, later, the Genoese—followed routes that converged on the shores of the Levant, as the eastern Mediterranean is sometimes known, coming either via the Caspian to the Black Sea, from Iran through Aleppo in Syria to the Mediterranean coast, or through the Red Sea to Alexandria.

By the sixteenth century the dominant power in the Middle East was that of the Ottoman Turks, originally a small tribe that rose to power in northwestern Anatolia (also called Asia Minor) and in the fifteenth century drove back the frontiers of the Byzantine Empire, finally capturing Istanbul

With the expansion of the Ottoman Empire, negotiations between foreigners and the court were frequently undertaken by middlemen, often of cosmopolitan experience and diverse religious and ethnic backgrounds. This anonymous drawing probably depicts a family of such a professional class in eighteenth-century Istanbul, perhaps Orthodox Greeks of local origin. The young boy to the right is dressed in emulation of the costume of an adult dragoman, or interpreter.

Detail of plate 27
Woman with Son and Daughter

(formerly known as Byzantium and Constantinople) in 1453. The Ottoman Empire continued to grow due to invasions into Europe by Süleyman the Magnificent, whose powerful and splendid court in Istanbul in the mid-sixteenth century attracted European merchants, craftsmen, and artists. Tales of exotic realms told by these voyagers fed European fascination with the Middle East.

Venetian control of trade routes was weakened in the latter half of the sixteenth century by the city's involvement in Italian conflicts, by the growth of Turkish sea power, and by the Portuguese's earlier discovery of a route to India via the Cape of Good Hope. The Venetians were joined in their commerce with the Levant by the French, who established a trading company in 1535, and the English, who did the same in 1581.

In the Near East, Europeans set up trading centers in the main cities of Istanbul, Izmir, Aleppo, Beirut, and Alexandria, where they lived in tightly organized commercial offices either in or resembling the indigenous caravanserais. Their relations with the Ottoman government were regulated by agreements known as capitulations. Contact with the local people was limited: few Europeans spoke either Arabic or Turkish, and their isolation was reinforced by fears of the plague and, in some areas, mutual hostility between Europeans and Muslims. Much of the trade exchange was in textiles. Early links had been established between the cotton industry in England and suppliers of raw cotton and purchasers of cotton goods in Syria. Tin and lead were also sold in return for spices, silk, currants, dyes, wines, and, from the seventeenth century, coffee.

Diplomatic activity, such as the renewal of capitulations, was usually left in the hands of leading foreign merchants, who were often aided by middlemen from such religious minorities as Christian Greeks or Armenians, or Jews. Officials of the English Levant Company initiated diplomatic relations between Britain and the Ottoman Empire, paving the way for greater political activity in the area in the nineteenth century. European visitors

PLATE 27
Woman with Son and Daughter
Anonymous
Mid-18th century
Watercolor and gouache, heightened with white, on vellum
18.1 x 25.0 cm

This anonymous European view of Cairo as seen from Giza (note the schematic pyramids in the lower right corner) dates from the latter part of the sixteenth century.

PLATE 28
View of Cairo, the Nile, and the Pyramids of Giza
Anonymous
Late 16th century
Watercolor and gouache, heightened with white, on laid paper
21.8 x 42.5 cm

As non-Muslims were kept distant from the places holy to Islam along the eastern coastal plain of Arabia, few European images of these sites exist. Smith probably copied this view of Mecca from an as yet unidentified source. Mecca is the birthplace of Muhammad, Prophet of Islam, and the focus of Islamic pilgrimage.

PLATE 29
Mecca
Charles Hamilton Smith
(1776-1859)
c. 1830
Pencil and watercolor
42.0 x 33.5 cm

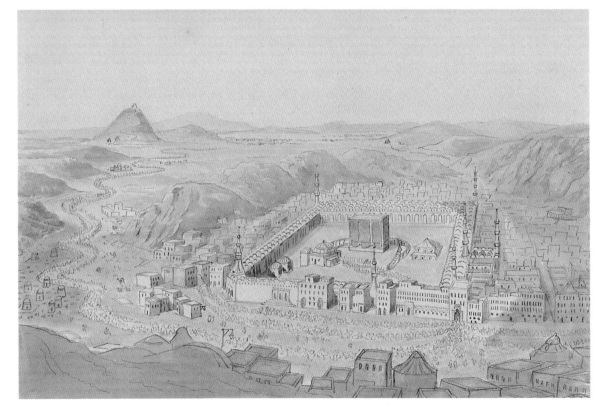

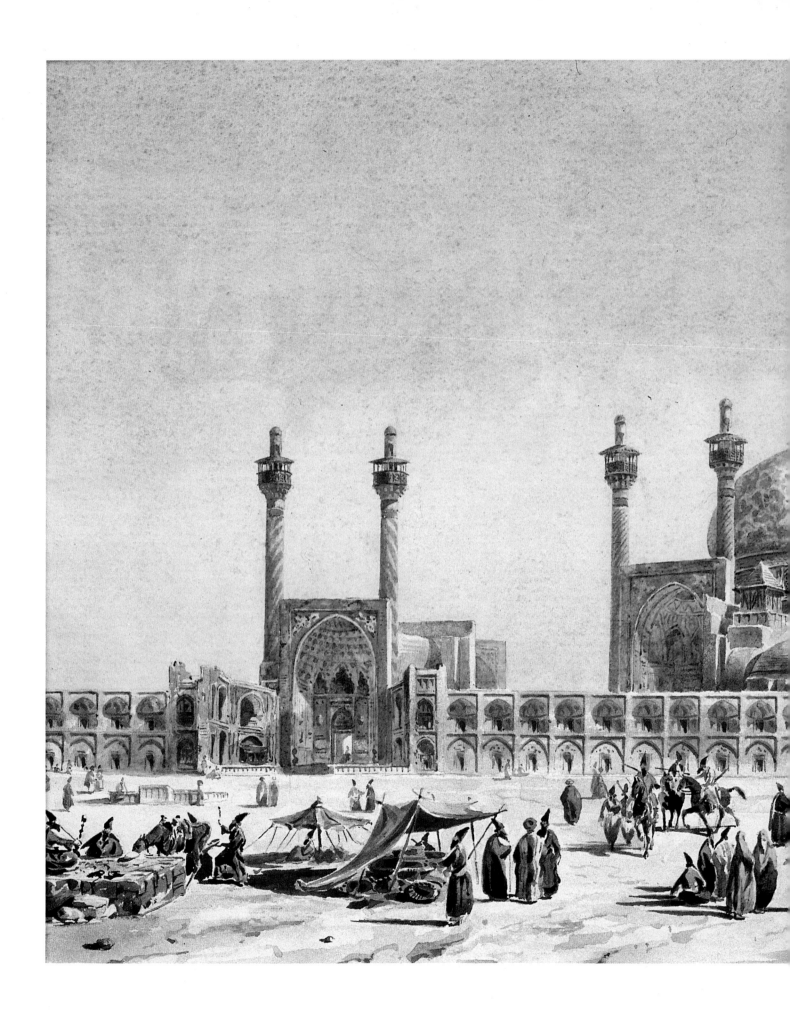

PLATE 30
Maydan-i Shah in Isfahan
Eugène-Napoléon
Flandin (1809-1876)
1841
Pencil and watercolor
21.5 x 34.6 cm

Mayer's extensive travels in the Middle East in the late eighteenth century resulted in numerous volumes of prints depicting views of important monuments. The watercolors grouped together here show how Mayer artfully arranged figures and landscape to create imposing compositions. *(Pls. 31, 32, 33)*

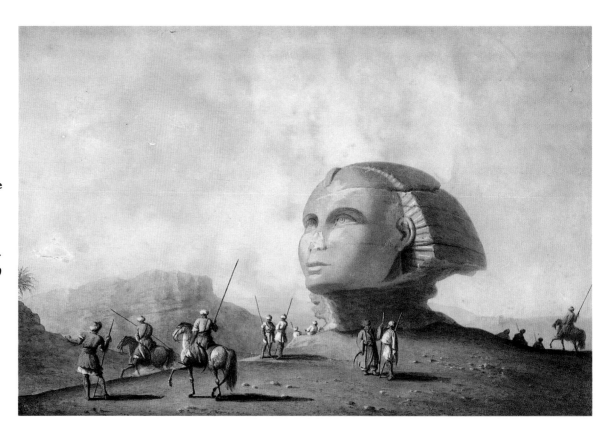

were deeply impressed by the grandeur of the court at Istanbul, this city "whose seven aspiring heads . . . are mostly crowned with magnificent mosques, all of white marble, being finished on the top with gilded spires that reflect the beames they receive with marvellous splendour."[1] Shakespeare's romantic description of Cleopatra's journey on the Nile, as found in *Antony and Cleopatra*, may have been inspired by the following account of the sultan's barge as being "one of the delicatest and rarest presence that ever I beheld . . . the whole frame soe set with opalls, rubies, emeralds, burnisht with gold, painted with flowers and graced with Inlaid work . . . that I am persuaded there is not such a bird cage in the world."[2]

Egypt during this early period was less welcoming to foreign merchants. Those who did trade from Alexandria were mostly French merchants from Marseilles, who offered protection to the few English merchants who tried to participate. To some extent the trade with India and further east on which Cairo had flourished in the fourteenth and fifteenth centuries was preempted by the discovery of the Cape route, so that Portuguese, Dutch, and English merchants no longer depended on the route via Egypt and the Red Sea. Non-Muslim merchants were not welcome in the Red Sea area, for fear that they would come too close to the holy places of Islam at Mecca and Medina.

Trade played a crucial role in stimulating European curiosity about Iran, which was initially aroused by the Venetians in the latter part of the thirteenth century. Iran and its inhabitants were more remote and an even greater source of wonder to Renaissance Europe than the Ottoman world. Direct trade with the countries of northern Europe was established by the early seventeenth century, at first via Russia but more satisfactorily through the Persian Gulf and thence via Baghdad and the Euphrates to Aleppo. However, European merchants based in India and the Far East were more successful in developing the Iranian trade than those coming from Syria or Russia, having the advantage of a link that had existed for five thousand

PLATE 32
The Tomb of Absalom,
Jerusalem
Luigi Mayer FSA
(c. 1750-1803)
c. 1792
Watercolor, on laid paper
17.7 x 29.8 cm

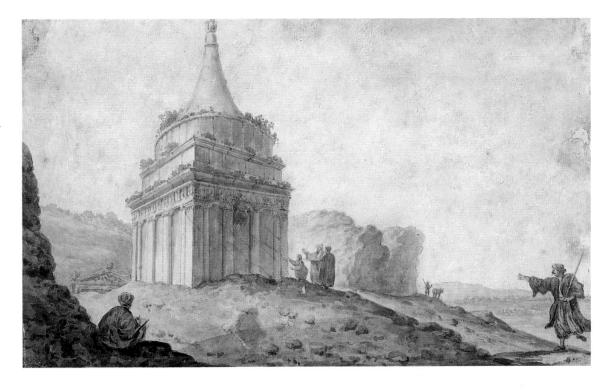

PLATE 33
Mosque Built within
Ancient Ruins in Latakia
Luigi Mayer FSA
(c. 1750-1803)
c. 1800
Watercolor and gouache,
heightened with white
26.1 x 32.7 cm

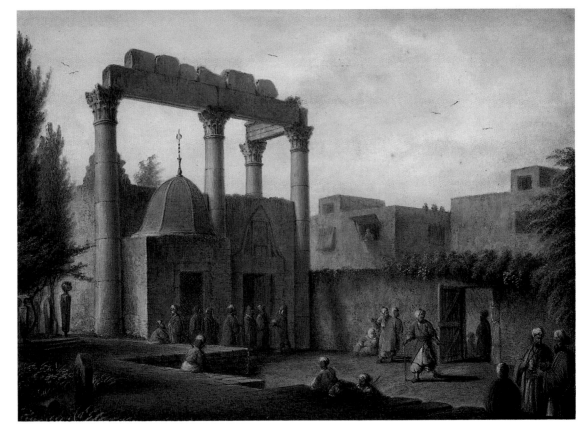

Amateur artists, such as those represented here, made their way to the Middle East. Often part of military or diplomatic entourages, they represented their encounters from a special vantage point, emphasizing contrasts in costumes and emblems of rank. *(Pls. 34, 35, 36)*

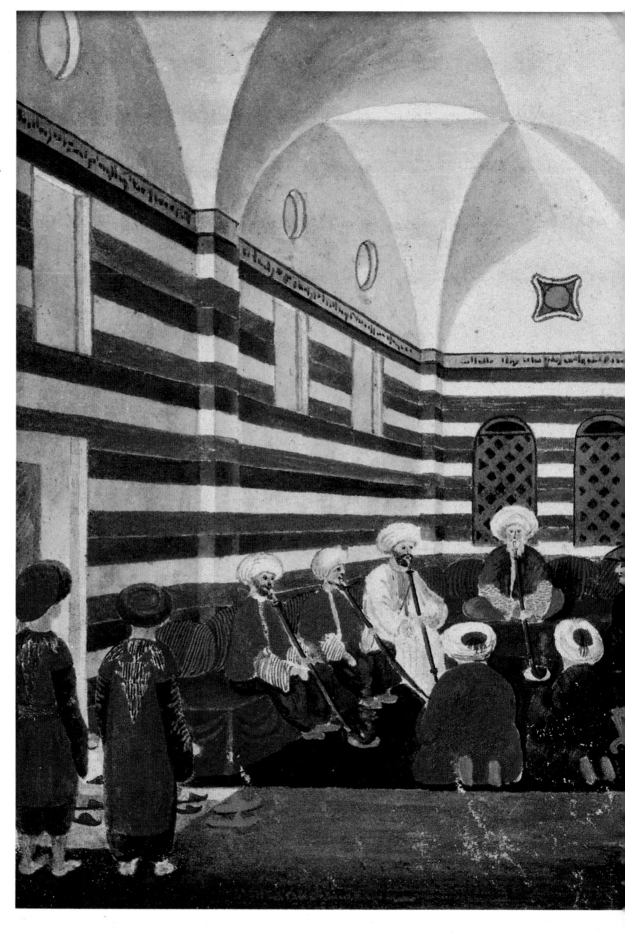

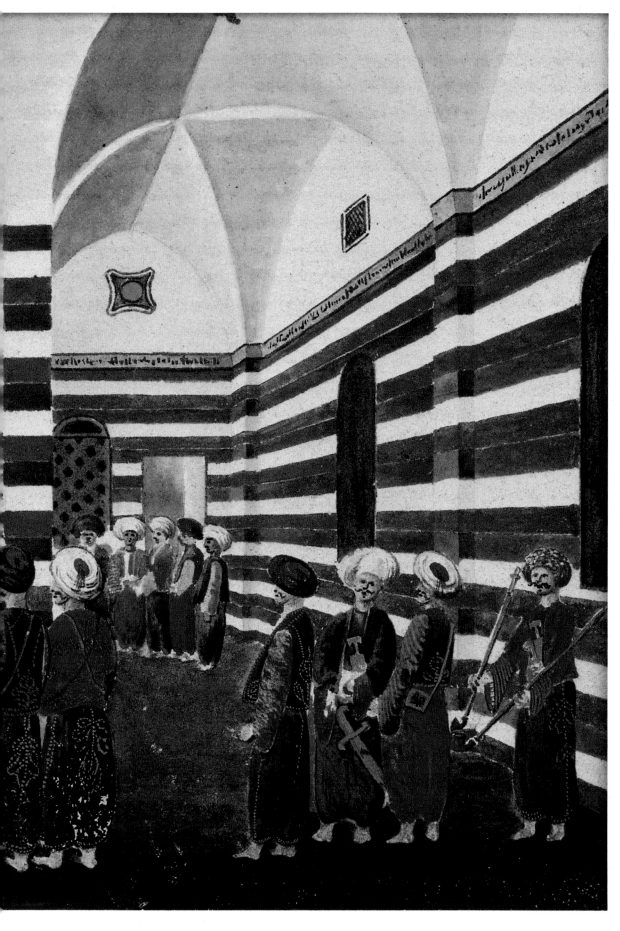

PLATE 34
Interview of the Reverend
Lewis Way with Amir
Bashir II at Bayt al-Din
Albert Way FSA (1805-1874)
1823
Watercolor and gouache
10.7 x 13.6 cm

63

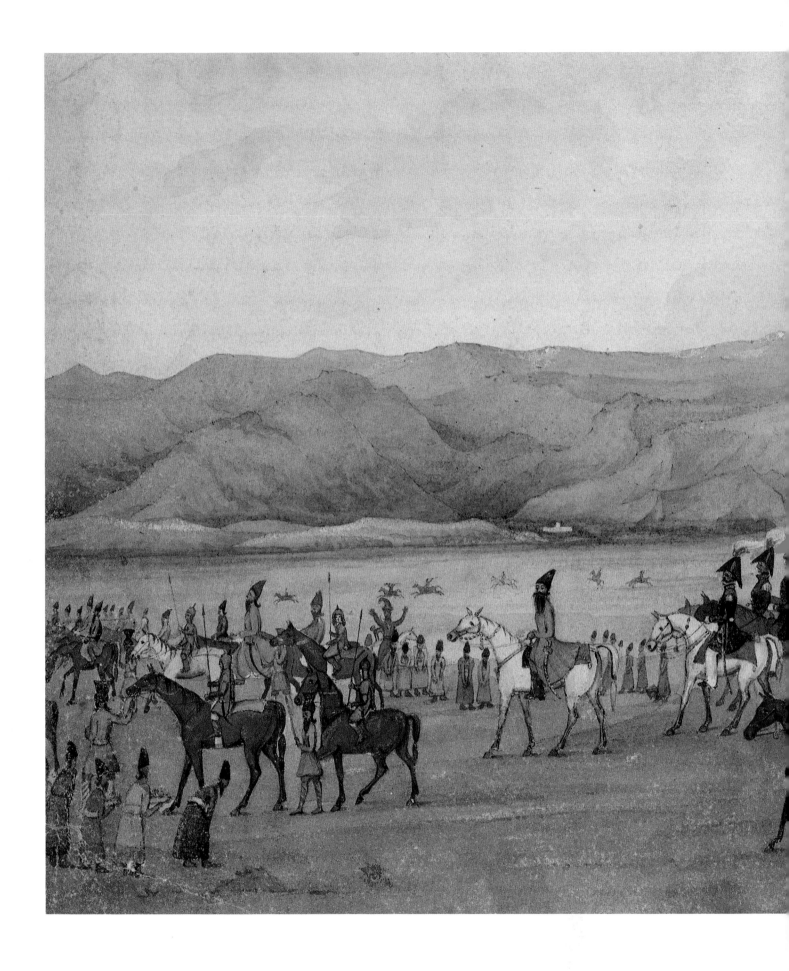

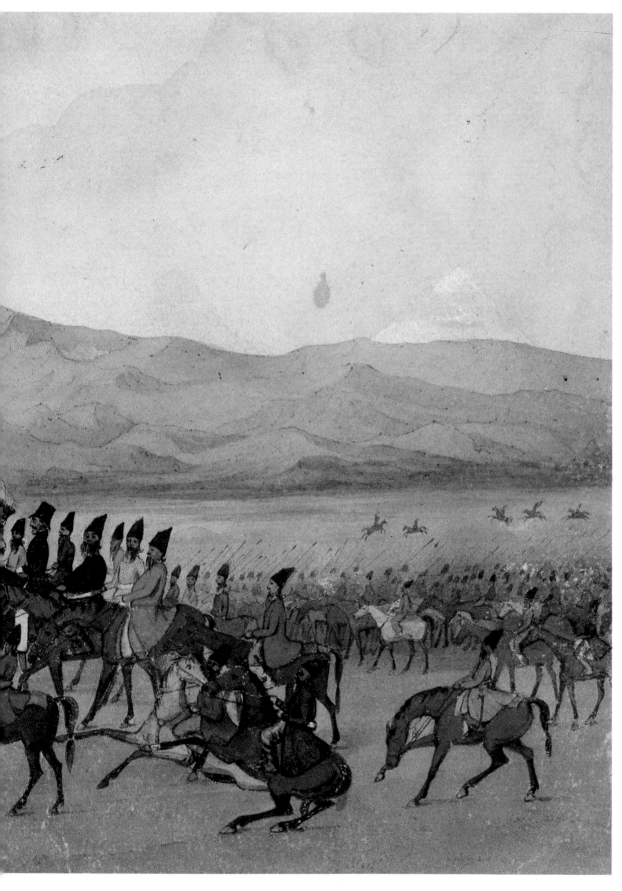

PLATE 35
Triumphal Entry of
Crown Prince Abbas
Mirza, son of Fath Ali
Shah, at Tehran
Godfrey Thomas Vigne
FRGS (1801-1863)
1833
Pencil and watercolor,
with pen and ink
21.2 x 35.4 cm

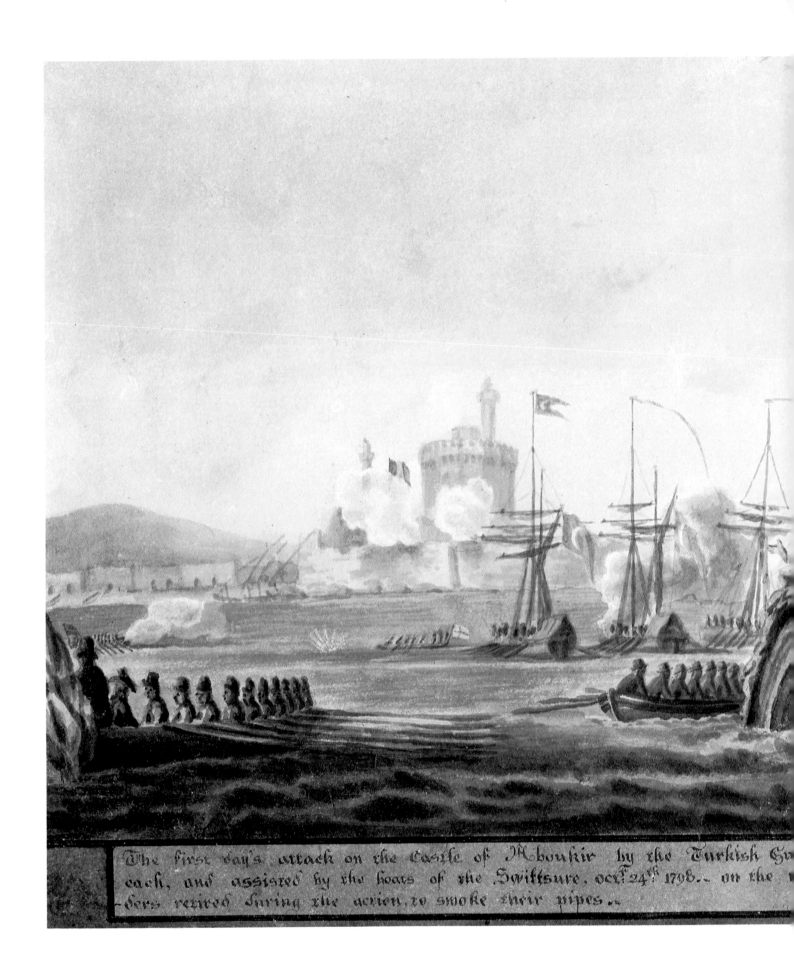

The first day's attack on the Castle of Aboukir by the Turkish Gu___ cast, and assisted by the boats of the Swiftsure, oct.r 24.th 1798.— on the ___ ___ers retired during the action, to smoke their pipes.—

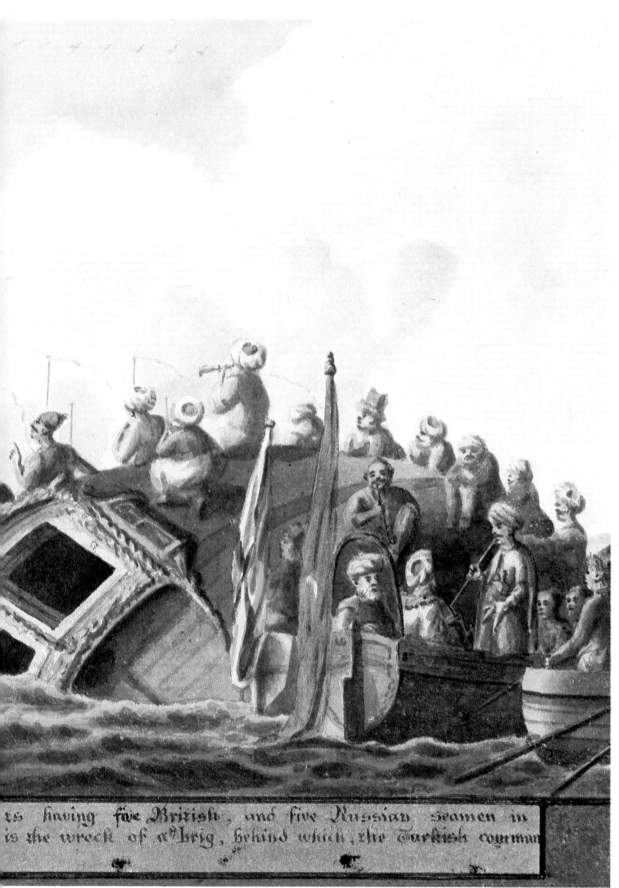

PLATE 36
The Battle at Abu Qir,
near Alexandria
Reverend Cooper
Willyams (1762-1816)
1798
Watercolor
21.8 x 36.2 cm

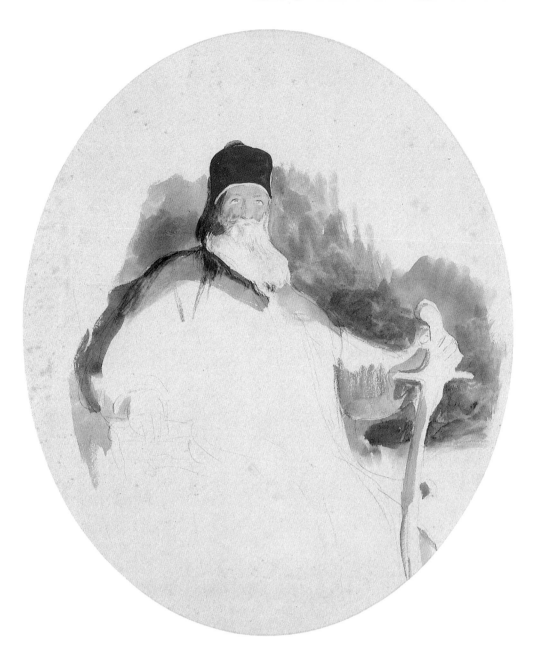

**Appointed Ottoman
governor of Egypt in
1805, Muhammad Ali
modernized both
commerce and trans-
portation, utilizing
the expertise of
Frenchmen who
stayed behind after
the official expulsion
of Napoleon's forces.**

PLATE 37
Muhammad Ali
Sir David Wilkie RA
(1785-1841)
1841
Pencil, black chalk, and
watercolor
34.7 x 29.1 cm

years. Dutch and English traders sweated out a precarious existence on the Iranian shores of the Gulf, traveling twice a year through the mountains to Isfahan to collect silk, the most valuable commodity of the trade.

Tales of opulence recounted by merchants and other travelers attracted a number of adventurers, including two English brothers, Anthony and Robert Sherley, who took the Euphrates Valley route to Iran at the end of the sixteenth century. Robert married an Armenian from Isfahan; portraits of the pair by Sir Anthony Van Dyke show them resplendent in Iranian costume, a style that was taken up by the Restoration court in England.

As knowledge of the Middle East grew through commercial and maritime contacts, so too did interest in its antique or classical past. Early merchants in the Levant collected statuary from classical sites, stimulating interest that by the mid-eighteenth century led to a number of scholars and antiquarians exploring the more accessible sites. Visual records of their findings were often made by professional artists, such as Luigi Mayer (pls. 31, 32, 33, 76), who was employed for almost two decades by the British ambassador in Istanbul, Sir Robert Ainslie, and is well represented in the Searight Collection. Antiquarianism was the great eighteenth-century hobby, with societies such as the (English) Society of Dilettanti founded for its encouragement. The accounts of Robert Wood visiting Palmyra, Richard Pococke

As a member of the East India Company Navy, Moresby worked on surveys of the Red Sea coasts, planning the logistics of steam-ship mail routes.

PLATE 38
Al-Muqalla on the Gulf of Aden
Captain Robert Moresby
(Active 1829-1852)
c. 1840
Watercolor, with pen and ink
36.2 x 45.2 cm

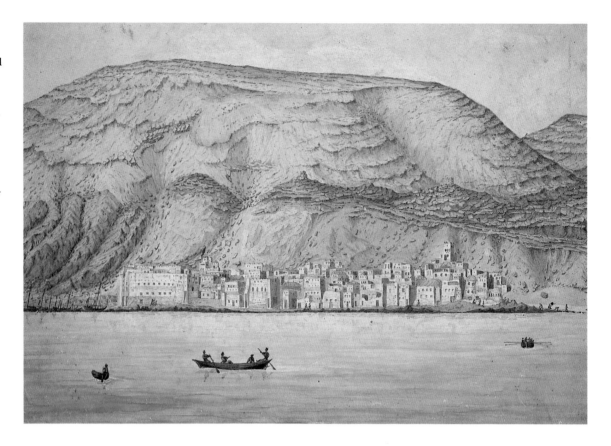

PLATE 39
Town and Harbor of Qusayr on the Red Sea
Captain Robert Moresby
(Active 1829-1852)
c. 1830
Watercolor, with pen and ink
26.2 x 39.4 cm

The careers of Prisse d'Avennes and Linant de Bellefonds represent the profound impact of the French in Egypt. Besides working in technical capacities for Muhammad Ali, both men contributed to European knowledge of ancient Egypt, often using their art to document excavations and discoveries. (*Pls. 40, 41, 42*)

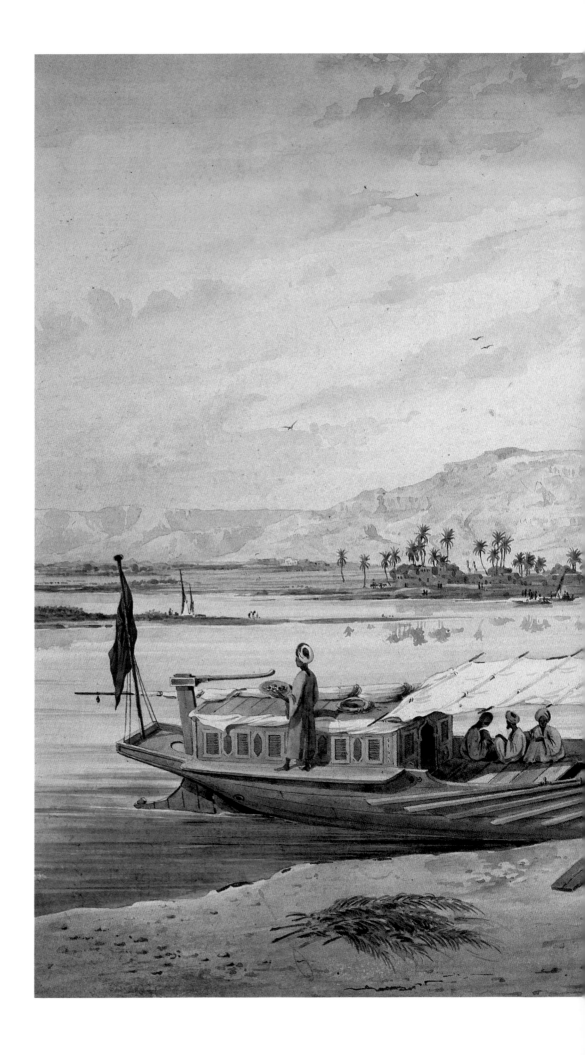

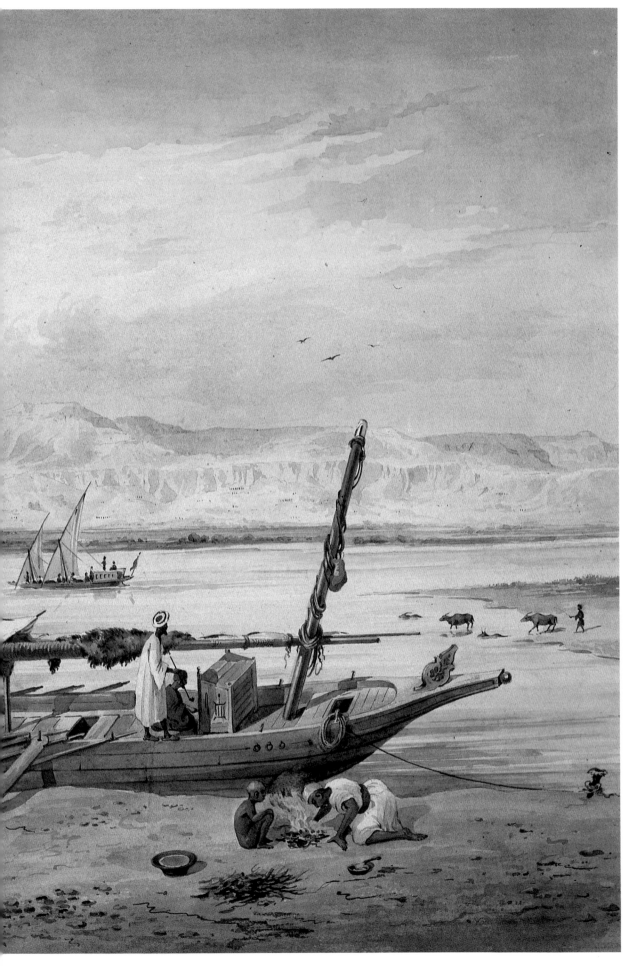

PLATE 40
*Qangah Moored on the
East Bank of the Nile at
Luxor*
Achille-Constant-
Théodore-Émile Prisse
d'Avennes (1807-1879)
c. 1840
Watercolor
25.1 x 33.7 cm

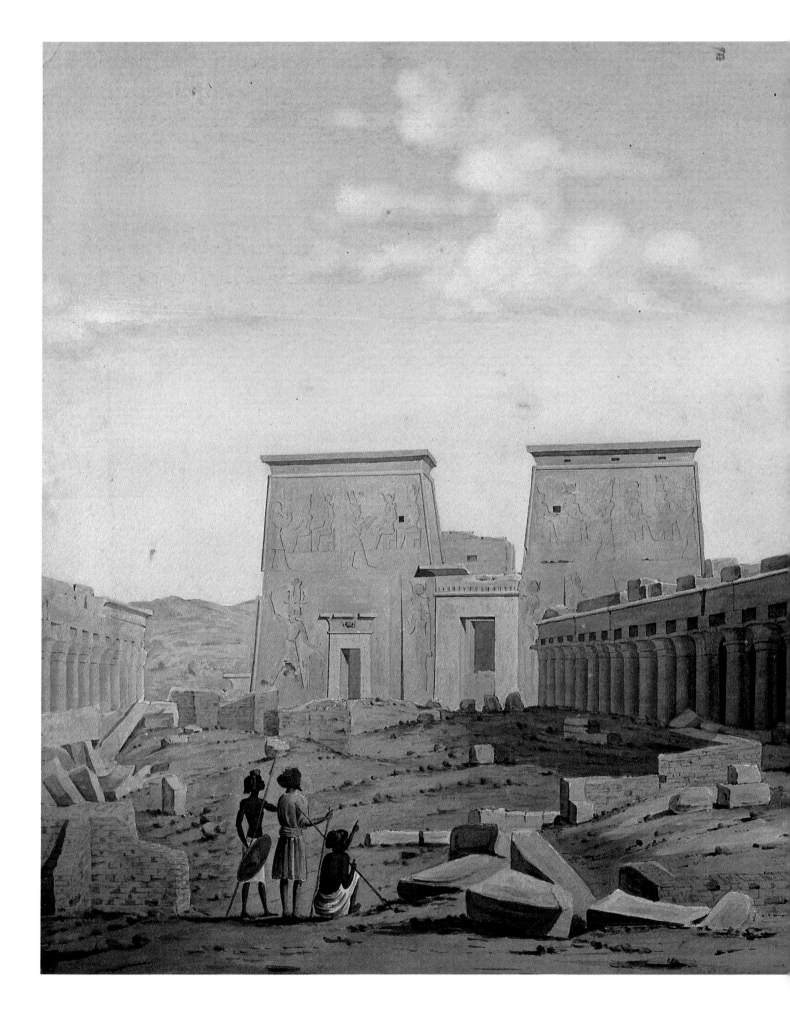

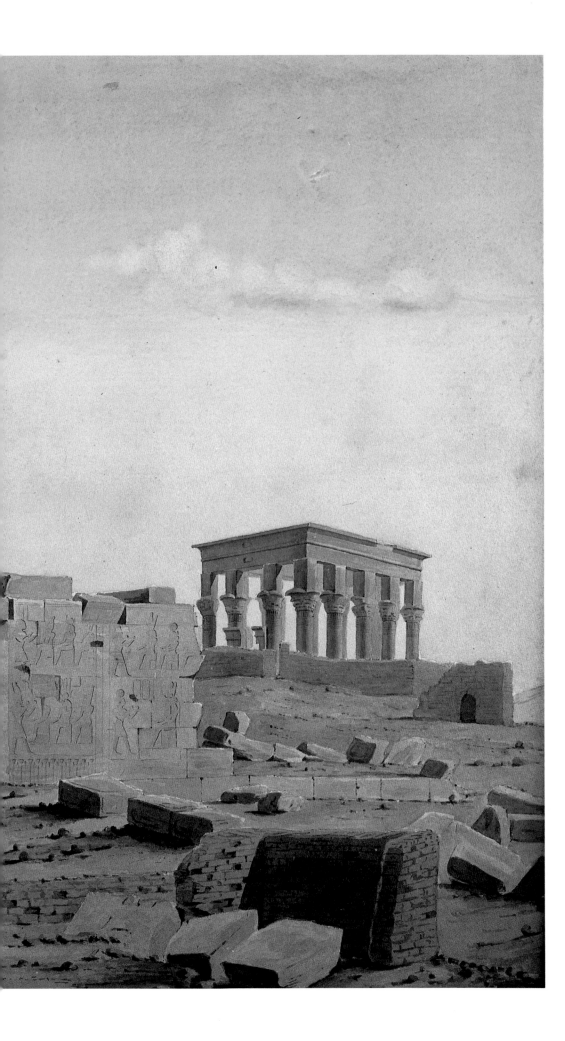

PLATE 41
Temple of Isis at Philae
Louis Maurice Adolphe
Linant de Bellefonds
(1799-1883)
c. 1846
Pencil and watercolor
34.1 x 50.8 cm

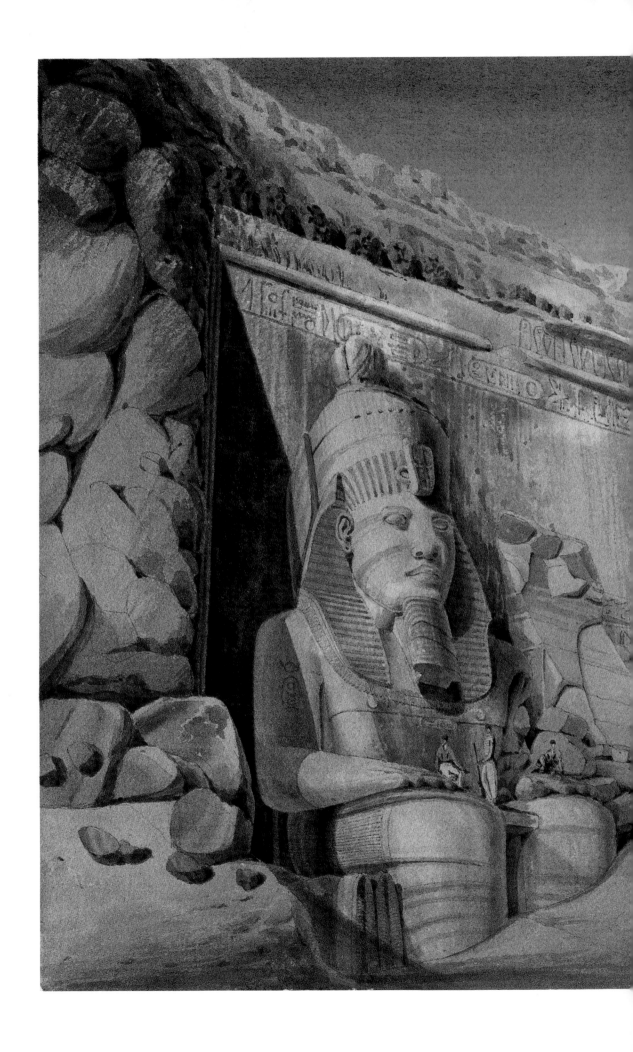

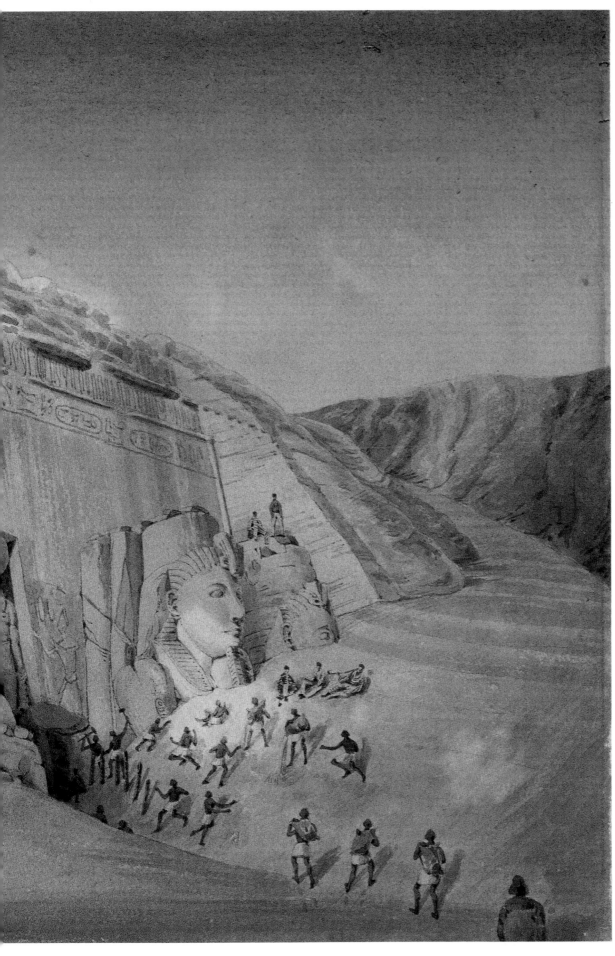

PLATE 42
Temple of Rameses II at
Abu Simbel
Attributed to Louis
Maurice Adolphe Linant
de Bellefonds (1799-1883)
c. 1818
Pencil and watercolor
17.1 x 23.9 cm

75

sailing up the Nile, the Frenchman Constantin-François Volney traversing the mountains of Lebanon, and the Dutchman Cornelius de Bruyn traveling in Iran fed the imaginations of their stay-at-home contemporaries, who responded by writing their own Gothic tales of romance and Oriental fairy tales. France set the fashion for adapting the Oriental tale to satirize contemporary society, as in Voltaire's *Zadig* and Montesquieu's *Lettres Persanes*.

The society they ridiculed shortly after erupted in revolution. Both this—the French Revolution—and the Industrial Revolution profoundly affected the Middle East. The number of Europeans operating in the region increased sharply, and a great many of them were skillful with pens, pencils, and paintbrushes. It is at this point that the Searight Collection takes off.

THE NINETEENTH CENTURY AND BEYOND

Several historians have recently corrected the traditional view of a Middle East consisting of crumbling autocracies. It has been pointed out that the French invasion of Egypt in 1798, the first conquest of a Muslim country by a European army since the Crusades, stimulated from within a process of reform and modernization. Napoleon's eastern schemes were mostly designed to divert attention from Europe, but they also attracted the attention of two other European powers. Russia, now well ensconced on the northern shores of the Black Sea, was concerned about security of access through the Dardanelles to the Mediterranean, while Britain, which was accumulating valuable territories in India, developed land routes that ran through the Ottoman Empire. Such concerns, combined with rival European claims to Balkan loyalties in the struggle for independence, gave rise to the "Eastern Question" that concerned European governments for much of the nineteenth century and formed a significant aspect of the background to many of the works in the Searight Collection. Most of these works are of the Ottoman Empire and Egypt, the most accessible areas of the Middle East and those most affected by European power politics.

Both the Ottoman and Egyptian governments tried to reform their administrations in response to fears of European encroachments. Such intentions, however, exposed weaknesses that led to less rather than more independence. The Ottoman government overhauled and centralized the imperial administration in an effort to facilitate tax collection. Far from being the "sick man of Europe," the government demonstrated remarkable flexibility and vigor. But the cost was high, aggravated by Great Power diplomacy associated with the Eastern Question and repeated military campaigns. One such campaign was the Crimean War, which brought a flock of artistic visitors to Istanbul. The rising cost of imports to the Ottomans led to increasing and regular foreign borrowing, foreign economic penetration, and in 1875 to bankruptcy.

A similar situation developed in Egypt, where its new ruler, Muhammad Ali, who was appointed the Ottoman sultan's viceroy in 1805, was determined to reform the country's administration and modernize its economy. In the process it employed a number of foreign experts, particularly French, whose watercolors and drawings are well represented in the collection. A series of ambitious rulers introduced programs of development and reform that required more money than could be raised from local revenue. Enormous debts were incurred for the Suez Canal under unfavorable agreements with Ferdinand de Lesseps. Modernization in Egypt, as in Turkey, led to increased imports, by mid-century to regular foreign borrowing, and by the mid-1870s to bankruptcy. Loan terms for the Egyptian govern-

Layard spearheaded archaeological investigation of the many mounds in the valleys of the Tigris and Euphrates Rivers in Iraq, discovering the cities of ancient Mesopotamia, such as the Assyrian centers of Nimrud, Nineveh, and Khorsabad. Cooper accompanied Layard on an expedition to the area sponsored by the British Museum in 1849-51. He produced sketches of the mounds and their ruins, as well as more finished works, such as watercolors commemorating events from earlier expeditions. *(Pls. 43, 44, 45, 46)*

PLATE 43
The Mound of Kuyunjik,
Site of Nineveh, near
Mosul
Frederick Charles Cooper
(1817- post 1868)
c. 1850
Pencil and watercolor
22.2 x 32.4 cm

PLATE 44
Entrance to the Southwest
Palace at Nimrud, near
Mosul
Frederick Charles Cooper
(1817- post 1868)
c. 1850
Pencil and watercolor
21.1 x 31.5 cm

PAGES 78-79: PLATE 45
Reconstruction of the
Throne Room in
Ashurnasirpal's Palace at
Nimrud, near Mosul
Sir Austen Henry Layard
(1817-1894)
c. 1849
Watercolor, with pen and
ink, heightened with white
55.5 x 87.8 cm

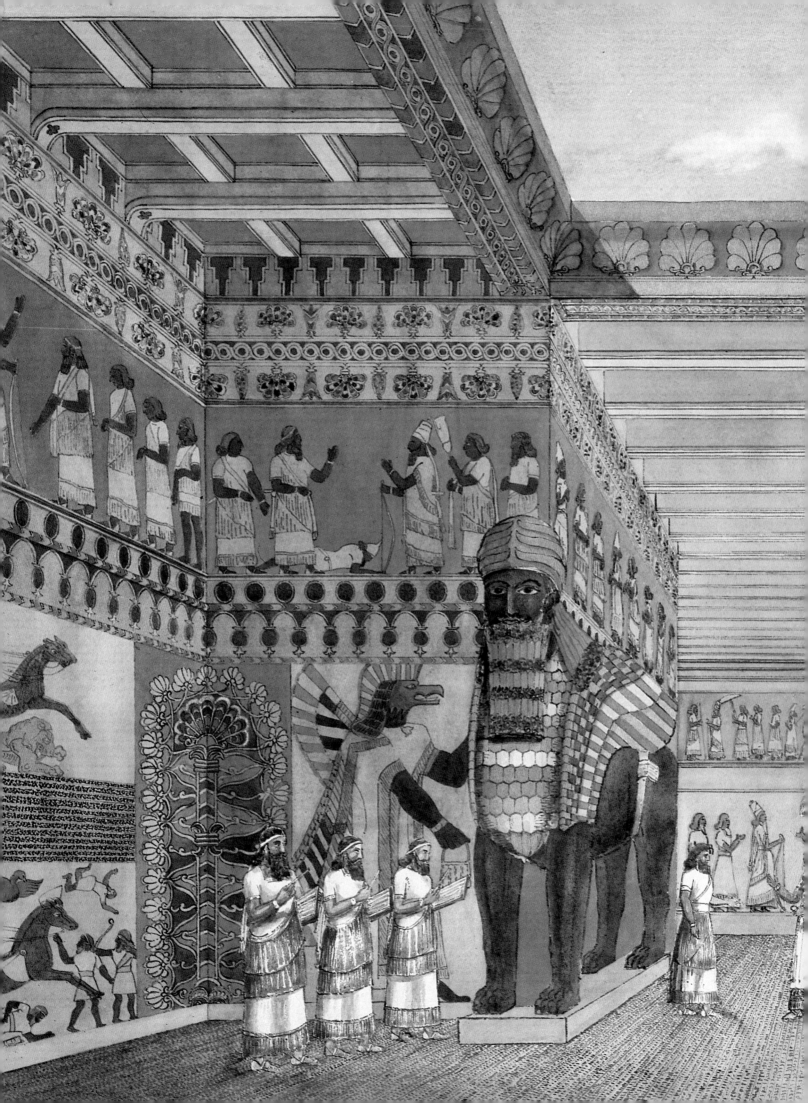

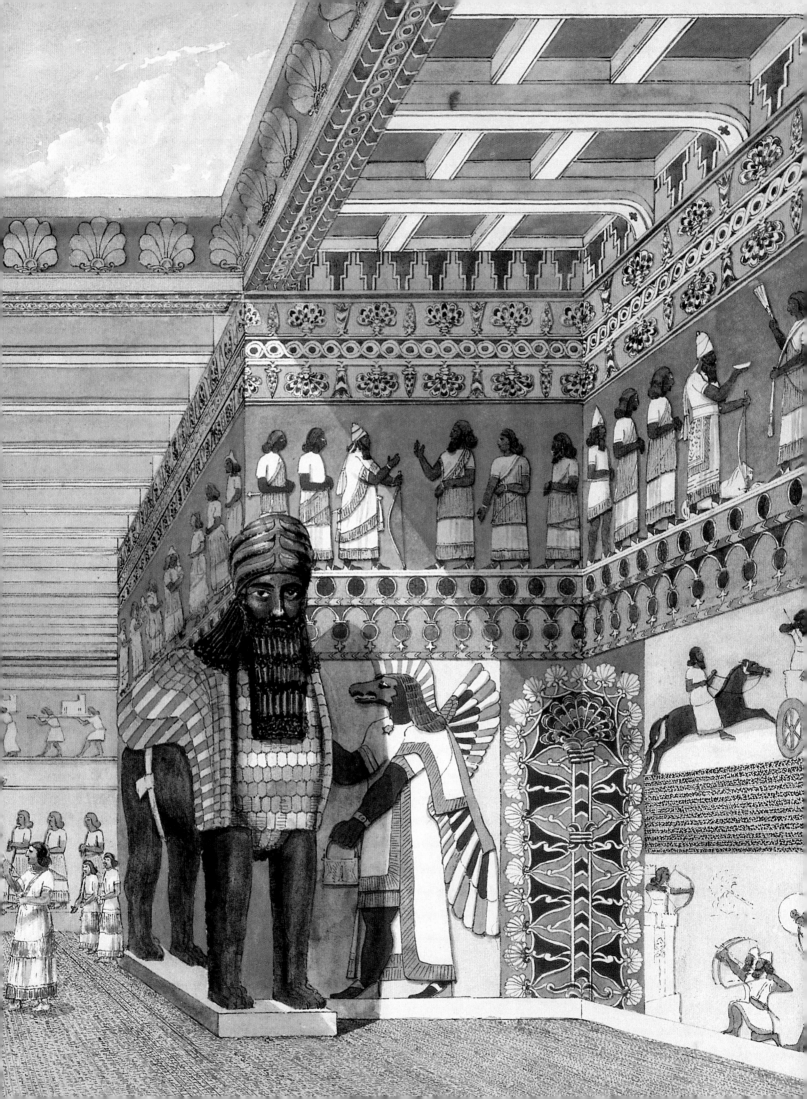

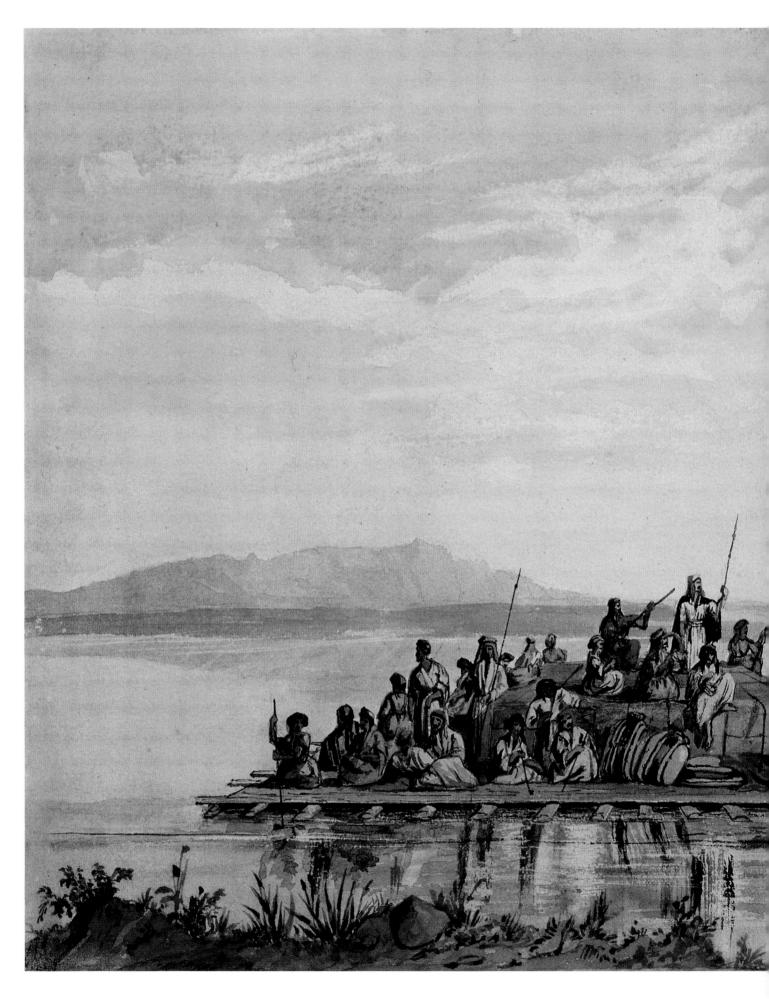

PLATE 46
Raft Conveying the Winged Bull down the Tigris River
Frederick Charles Cooper
(1817-post 1868)
c. 1850
Pencil and watercolor
23.0 x 33.0 cm

ment were considerably harsher than those for the Ottoman government. Egyptian protests erupted with riots in 1881-82 (the earliest demonstration of modern Egyptian nationalism), which were led by an Egyptian army officer, Colonel Ahmad Urabi. The riots resulted in the British bombardment of Alexandria and the subsequent occupation of Egypt. Alleged financial incompetence on the part of the Egyptian ruler was used by the British financial controller, Sir Evelyn Baring, later Lord Cromer, in his arguments to the British government to justify continued occupation.

The significance of the Industrial Revolution in this process of foreign infiltration lay initially in the increasing output of British manufactures in the early nineteenth century. In this process the Middle East became a market of major importance for British goods. In earlier periods the bulk of British trade was with Turkish ports such as Istanbul and Izmir; Egypt only became a significant market from the 1840s with the greater liberalization of trade initiated by Muhammad Ali. With the increase in trade came growth in the number of European residents, particularly in ports such as Alexandria and Beirut, and more artists traveled in the area, inspired by the challenge of representing the diverse peoples, exotic customs, and unfamiliar landscapes of the region.

Transportation also improved with the introduction of steamboats, which allowed vessels steaming through the Mediterranean to coordinate their arrivals with that of other ships at Suez in the Red Sea. The initial impetus came from the need for faster mail service to India, but soon passengers were making their way across Egypt on the so-called Overland Route. Increasing numbers of travelers stopped to examine and wonder at the awesome ruins of ancient Egypt along the banks of the Nile River, which had been given compelling publicity by the French scholars who had accompanied Napoleon in 1798. Some of those who came to the Middle East stayed for a considerable length of time—technicians such as Linant de Bellefonds (pls. 41, 42) and Prisse d'Avennes (pl. 40); the antiquarian Robert Hay and his retinue of artists; and literary and artistic commentators, including Edward Lane, author of *Manners and Customs of the Modern Egyptians*, which is still one of the best guides to the country, and the artist J. F. Lewis (pls. 4, 15), both of whom lived in Cairo for several years.

This political and economic involvement of Europe, so well reflected in the collection, was far greater in the Near East—Anatolia, the Levant, Egypt—than in Iraq and Iran. Involvement in Iraq was largely governed by the British in India and was almost exclusively commercial until the 1890s, when German proposals for a Baghdad railway suddenly aroused fierce political opposition in Britain. European commercial interest in Iran foundered on Anglo-Russian rivalry for dominance, although the antics of the so-called Great Game of which this rivalry was part were largely motivated by the ramifications of Great Power relations in Europe. The few paintings of these areas in the Searight Collection, being mainly by visiting diplomats or soldiers, reflect this exclusion of civil interests, and only the activities of Henry Layard at the ancient archaeological sites of northern Iraq were recorded by a professional artist, F. C. Cooper (pls. 43, 44, 46).

The Suez Canal was opened with a magnificent flourish in 1869. Europe's royalty steamed to its inauguration aboard the most up-to-date vessels, feasted at sumptuous entertainments, and managed to navigate the narrow canal from one end to the other without too many mishaps. Artist William Simpson painted the emperor of Austria struggling up a pyramid (pl. 72), symptomatic of a new type of tourist interest in the area. Shortly before the inauguration, Thomas Cook, who was destined to become a fa-

Expanded archaeological exploration in the nineteenth century tentatively identified many sites from Jordan to the Mediterranean as cities mentioned in the Bible. European tourism to these spots increased, and Jerusalem became an important center. (Pls. 47, 48, 49)

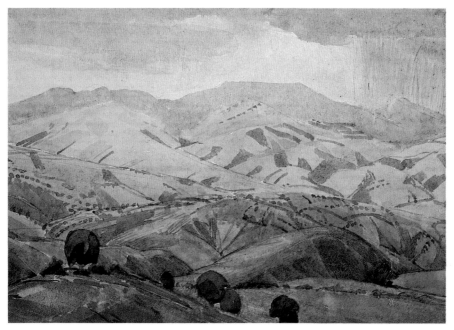

mous name in the tourism field, assembled his first party of visitors and took them not only to Egypt but also to other areas of the Near East, a sign that a remarkable degree of stable administration and security had been achieved by the regimes of Istanbul and Cairo.

Before the nineteenth century, links with biblical sites had been maintained by a trickle of European pilgrims. They were conducted round the sites by local monks whose knowledge, according to one seventeenth-century English visitor, was divided into "Apparent Truths, Manifest Truths, and Things Doubtful."[3] Pilgrimage was stimulated in the nineteenth century by archaeology, for many of the discoveries in Egypt and Iraq were valued most highly for the light they shed on the Bible. Artists such as W. H. Bartlett (pls. 5, 50, 51) and David Roberts (pls. 52, 73) also encouraged this interest, as their lavishly illustrated books, published mainly in the 1840s, appeared on Victorian coffee tables and provided—particularly in the case of Bartlett—a fine commentary on the areas through which they traveled. Edward Lear (pls. 47, 82) found Middle Eastern sites "full of melancholy glory, exquisite beauty & a world of past history of all ages."[4] While many visitors, including Lear, suffered hardships and discomforts, others toured in considerable style, such as an Englishwoman who traveled to Jerusalem

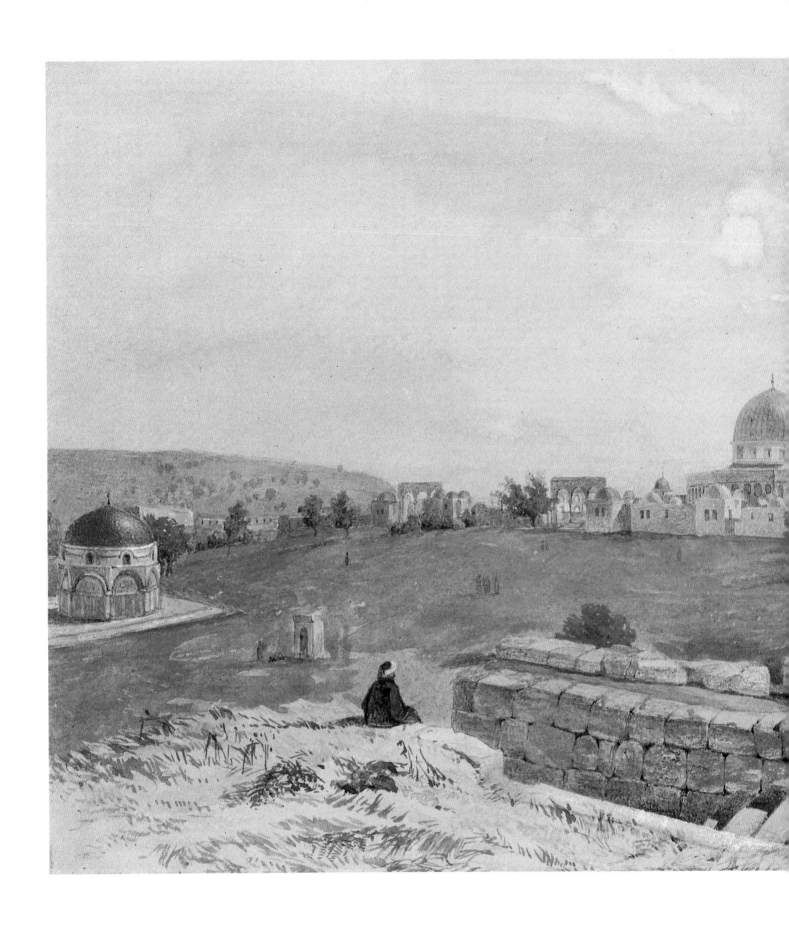

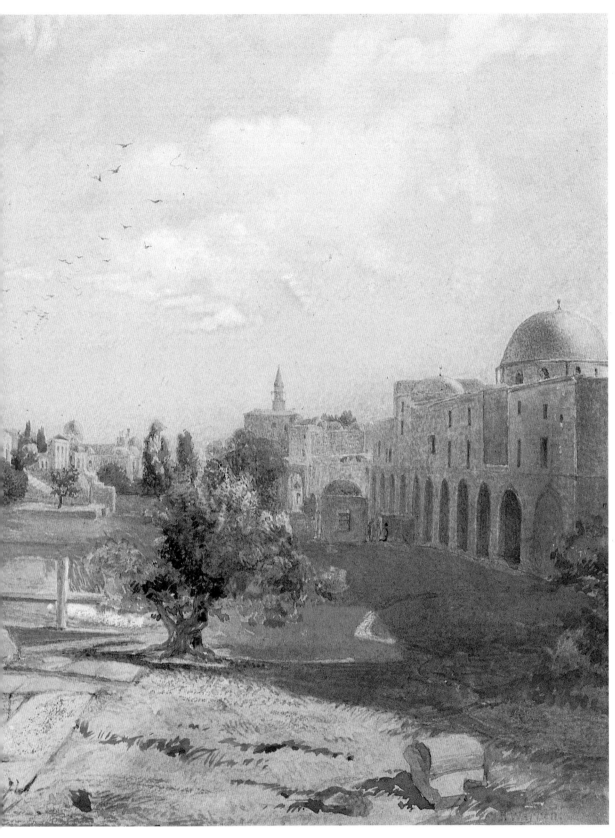

PLATE 49
Haram al-Sharif with the
Dome of the Rock,
Jerusalem
Henry Warren PNWS
(1794-1879)
c. 1853
Pencil, watercolor, and
gouache, heightened
with white
20.9 x 36.6 cm

As the nineteenth century progressed, European tourism in the Middle East focused on archaeological wonders, such as the rock-carved tombs of Petra in Jordan. On an 1834 trip to the Middle East, Bartlett, a prolific topographical artist, met the famed expatriate of an earlier generation, Lady Hester Stanhope, and made a wash drawing of the Lebanese village of Jouni, near which she resided.

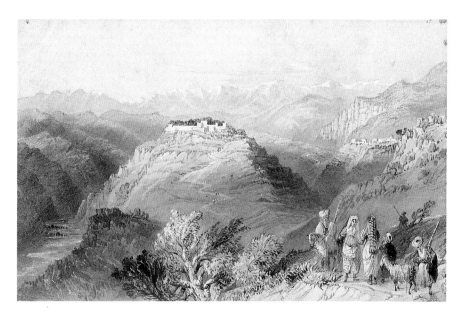

PLATE 50
Jouni
William Henry Bartlett
(1809-1854)
c. 1834
Pen, ink, and wash
12.1 x 19.0 cm

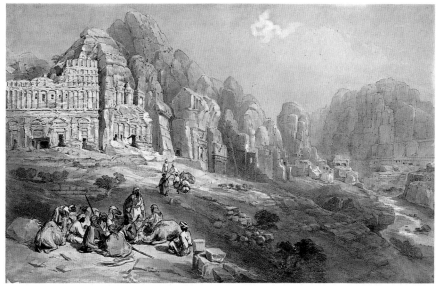

PLATE 51
Petra
William Henry Bartlett
(1809-1854)
c. 1848
Pencil, watercolor, and gouache, with pen and ink, heightened with white
22.3 x 35.9 cm

in 1860, sleeping in a camp bed surrounded by muslin curtains and set on a tent floor covered with Oriental rugs, and dining on apricot ices and other delicacies.

Tourism in Egypt even before Thomas Cook was greatly inspired by *Letters from Egypt*, first published in 1865, whose author, Lady Lucie Duff Gordon, tried to cure her tuberculosis by living in Upper Egypt. "The English milord, extinct on the Continent, has revived in Egypt," she wrote, frowning somewhat on the rows of boats lining the Nile River at Luxor. Thomas Cook's son John even built a special hotel at Luxor to cater to invalids attracted by Lucie's touching references to her health: "I now feel so much like living a little bit longer that I will ask you to send me a cargo of medicines," she wrote to her husband only a few weeks before her death.[5]

THE SEARIGHT COLLECTION

Lucie Duff Gordon was no professional commentator on other peoples' affairs, yet her reflections on the Egypt of her day are among the most acute recorded by her contemporaries. The same is true of the many amateur artists, including Maria Harriett Mathias (pls. 74, 75) and Godfrey Vigne (pls. 35, 56), whose paintings were collected by Rodney

Jerusalem rests on many layers of history and faith. The Dome of the Rock encloses the place worshipped as the point from which the Prophet of Islam, Muhammad, ascended to heaven. Nearby is the location of the Temple of Solomon, built for the king of the ancient Hebrews. In another quarter, the Church of the Holy Sepulchre is honored as the site of Jesus' tomb. *(Pls. 52, 53, 54, 55)*

PLATE 52
Chapel of Saint Helena in the Church of the Holy Sepulchre, Jerusalem
Attributed to David Roberts RA (1796-1864)
c. 1842
Pencil, watercolor, and gouache, heightened with white
17.3 x 21.7 cm

PLATE 53
Interior of the Dome of the Rock, Jerusalem
John Fulleylove RI (1845-1908)
1901
Pencil
26.0 x 36.2 cm

PLATE 54
Interior of the Dome of the Rock, Jerusalem
Carl Friedrich Heinrich Werner (1808-1894)
1863
Watercolor
50.3 x 34.7 cm

OPPOSITE: PLATE 55
Entrance to the Church of the Holy Sepulchre, Jerusalem
Thomas Allom FRIBA (1804-1872)
c. 1838
Pencil and watercolor
28 x 21.2 cm

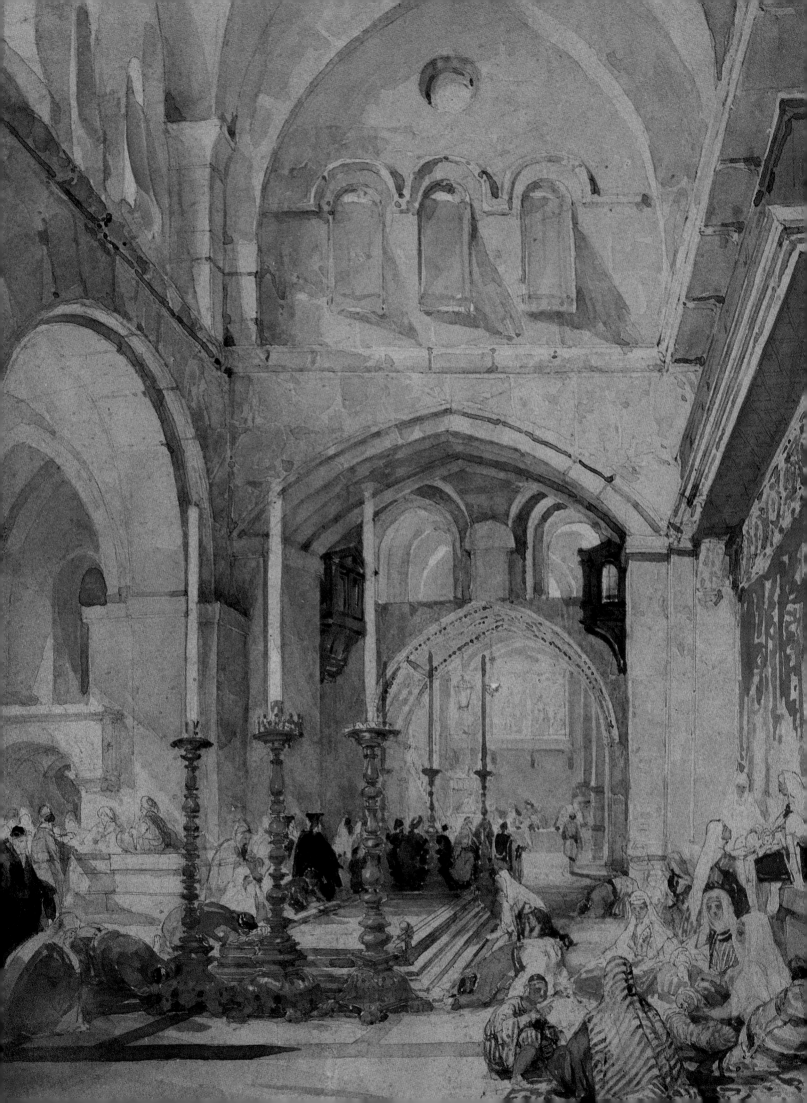

Haydar Pasha was the Ottoman governor of Jerusalem.

PLATE 56
Haydar Pasha
Attributed to Godfrey
Thomas Vigne FRGS
(1801-1863)
1844
Pencil and watercolor,
with pen and ink
27.5 x 19.0 cm

Searight, himself an amateur draftsman (a talent he always claimed enabled him to detect a bargain that others might overlook). My father's collection of watercolors, prints, drawings, and books on the Middle East was mostly made between the mid-1960s, when he retired from a career which had taken him so frequently to the area, and the end of the 1970s. By that time the rise in the price of oil, which led to rapid modernization in Arabia, an increase in the number of people living and working in the region, and heightened interest in the area, had pushed the prices of such objects beyond his reach. Whether this growth in Western political, commercial, and financial involvement in the region led to greater understanding has been much debated, in particular by Edward Said in *Orientalism* (1978), a cultural study of European literary and political attitudes toward the region, which has been influential in arguing a lack of comprehension.

Rodney Searight, who died in 1991, was typical of a generation of mid-twentieth-century entrepreneurs and diplomats for whom Said's arguments would have seemed irrelevant, concerned as they were mainly with the strategic and commercial significance of the Middle East and the Arab world. Few of the works in the Searight Collection fall into the category of Orientalism that my father described as "all houris and harems." In this respect the collection reflects his life's work and his attitude toward the region, much as it does those of the merchants, politicians, technicians, soldiers, artistic and literary commentators, and tourists who became acquainted with the area in the nineteenth century.

The communications revolution of the nineteenth century, which was stimulated by improvements in steamboats, railways, steam dredgers excavating the Suez Canal, the telegraph, and printing techniques, was largely the work of Europeans in which Rodney Searight himself later took part. To a large extent it was this revolution, combined with the impact of two earlier revolutions—the French and the Industrial—that in the years before World War I led to the emergence of a nationalist, Arab, and Islamic reaction to the European presence. In due course this affected my father's own work in the area. In 1951 he left Cairo in the wake of the "Black Saturday" riots that led to the ending of the British presence in Egypt, the emergence of Gamal Abd al-Nasser as Egyptian leader, and to the Suez Crisis of 1956.

Retirement in 1966 put collecting at the top of my father's list of priorities, and in 1969 he held his first exhibition at Leighton House in Kensington, London, breaking new ground in demonstrating the breadth of interest that nineteenth-century Europe had evinced in the Middle East. Critical acclaim encouraged him to continue expanding the collection, including in it contemporary volumes of travels, many of them illustrated with engravings of which he now possessed the original watercolors. The artworks document a world that was—a time when artists sought to capture their own responses to new and unfolding experiences. The Searight Collection stands today as a vivid and unique record of the impact of both ancient and modern cultures of the Middle East on nineteenth-century Europe.

NOTES

1. George Sandys, *A Relation of a Journey* (London, 1615), p. 53.

2. Robert Withers, *A description of the Seraglio*, published by Samuel Purchas in his *Hakluytus Posthumous or Purchas His Pilgrimes*, ed. Purchas (London, 1625), p. 128.

3. William Biddulph, *Travels...into Africa, Asia, etc.* (London, 1609), p. 123.

4. Edward Lear, *Letters*, ed. Lady Constance Strachey (London, 1907), p. 106.

5. Lucie Duff Gordon, *Letters*, ed. Sarah Searight (London, 1983), p. 141.

THE ARTISTS

Charles Newton

Wen I visited Rodney Searight to view his collection before it came to the Victoria and Albert Museum in 1985 and saw pictures covering the walls and filling plan chests everywhere in his home, I had an inkling of how huge a range of artists, subjects, and themes his collection encompassed. The subject of Orientalism has been very popular in the last two decades and has engendered critical debate, with much attention given to the works of European and American artists who portrayed their romantic or realistic impressions of the exotic sites and scenes of the Islamic lands, generally focusing on the regions bordering the Mediterranean in northern Africa and western Asia. The Searight Collection embodies the valuable truth that painters and sketchers of Orientalist themes are not one specific kind of artist but include all sorts and conditions of men and women.

Adventurers, amateur painters, anthropologists, archaeologists, architects, businessmen, convalescents, diplomats, drug-takers, engineers, explorers, historians, illustrators, interior decorators, jacks-of-all-trades, linguists, looters of antiquities, merchants, missionaries, refugees, renegades, scientists, sensualists, soldiers, spies, theater-scene painters, tourists, treasure hunters, war correspondents: these are just a few of the various groupings from the West known to have painted or drawn the East. Many of these categories are represented in the Searight Collection, with some artists appearing under several headings.

What do the more than two thousand watercolors and drawings, several thousand prints, and several hundred illustrated books that Rodney Searight collected have in common? Is it merely that they depict things or places in certain geographical areas under the influence of an Islamic ethos? How should the pictures be divided and categorized? Are there any underlying themes beyond that of mere region?

Although the over seven hundred artists and the subjects they depicted do fill an overwhelming number of categories, Rodney Searight imposed a simple and intelligent theme in his collection of "visions" of the Middle East. As a true collector and connoisseur, he felt strongly about the Middle East, and as an amateur painter himself, he had tried to record it. He collected only those pictures he found intrinsically interesting. This selective eye led him to acquire few of the endless pictures of carpet sellers, camels, harem and market scenes, and the pyramids that flooded the European market. Thus a large category of Orientalist painting is omitted.

Almost without exception, the information that a picture carried

Charles Newton is Deputy Head of Designs in the Prints, Drawings, and Paintings Collection, Victoria and Albert Museum, London.

DETAIL OF PLATE 73
Grand Cairo

93

This drawing, attributed to the famous adventurer who toured the Arabian coast of the Red Sea disguised as a Muslim, depicts a landscape reproduced in both French and English editions of a pictorial travelogue he authored in the early nineteenth century.

PLATE 57
Al-Muzdalifah
Attributed to Ali Bey el Abbassi, pseudonym of Domingo Badia y Leblich (1766-1818)
c. 1805
Pen, ink, and wash
12.4 x 16.5 cm

was as important to Rodney Searight as the artist or the painterly qualities of the image, and sometimes more so. He experienced keenly the thrill of the chase as he hunted for pictures in dusty antique shops or participated in the splendor of viewing days at the major auction houses. The delight of discovery—of recognizing the place depicted, attributing the work correctly to an artist, and knowing what the subject meant in the history of his chosen region—added to his pleasure, and subsequently to ours, as he rescued from oblivion unjustly neglected artists and their works. Rodney Searight pounced upon several drawings by Godfrey Thomas Vigne, for example, that were offered for sale in a wheelbarrow in the countryside of Wales.

Rodney Searight did not buy many oil paintings, simply because they were often not as interesting as, and were far more expensive than, watercolors or drawings of greater value in terms of historical and topographical information. Artists in the Searight Collection range from naive anonymous painters to such famous professionals as David Roberts (pls. 52, 73), David Wilkie (pl. 37), Baron Dominique Vivant Denon (pls. 58, 59), Alexandre-Gabriel Decamps, Mariano Fortuny y Marsal, and perhaps the most skilled technician of watercolor ever, John Frederick Lewis (pls. 4, 15).

Rodney Searight's approach was subtle: he must have realized very early that an amateur drawing might be a more literal and truthful representation of a certain subject than the work of some professionals. He knew that often an amateur was not skilled enough to provide picturesque fantasies in the way that a professional was able to do to please a patron. Paradoxically, the amateur's lack of skill might mean a more faithful representation. Amateurs by definition painted what attracted them, and although they often imitated current fashions in representation, frequently their primary motivation was to record exactly what they saw and experienced. This approach resulted in valuable documentation of sites damaged or destroyed before the use of photography became widespread.

Another, more subtle, theme underlies the rapid gathering together of this bank of exotic images. Surveying the diversity of the whole collection arouses a feeling of exquisite melancholy, as if looking through a window at

As accomplished academic artist, eminent intellectual, and Napoleon's fine arts administrator, Vivant Denon advanced French interest in the history and culture of Egypt. His travels in Egypt produced many drawings which were later used as book illustrations. (Pls. 58, 59)

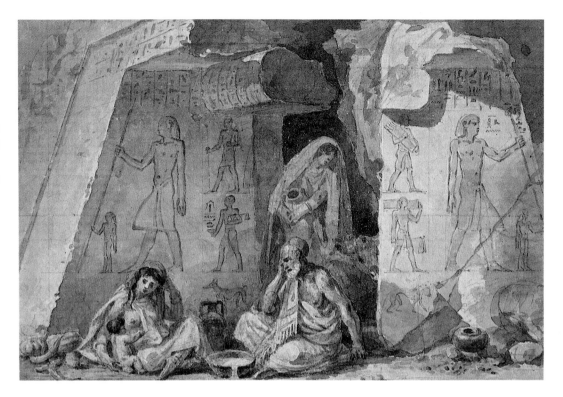

a strange world that is now rapidly disappearing. It was precisely because the Middle East felt and looked so different to Westerners—and was so obviously changing and vanishing—that such a great range of Westerners attempted to depict it. If it had looked like London or Paris, there would have been little burning desire to set down a representation. The East was, and is, rendered in a vast number of ways, not all of them by any means derogatory or patronizing or inaccurate, though some works are, alas, all three.

Think of all the categorizations of Western artists who depicted the East. Is there any reason why they should all see the East in the same way? Every shade of feeling and attitude is evident among them, because they were individuals with different histories. And observation often replaced supposition for those artists who traveled or lived in the Middle East.

The word "harem," derived from the Arabic *haram*, which denotes a forbidden place, a sanctuary, refers to private and secluded quarters for the ladies of the house, female servants, and children. In the European mind the two concepts were combined and the idea of the harem as a forbidden place full of women evolved, which excited much curiosity and was the object of numerous artists' attention. What most Westerners do not realize, even now, is the depth of offense that was given by certain paintings, although they looked innocuous to Western eyes. An example in the Searight Collection is Amadeo Preziosi's painting of the harem (pl. 60), which is not prurient by modern or even Victorian standards. Two women, one a servant or slave, both fully dressed, appear in a room, into which enters a Turk, who is understood to be the husband. There is no obvious element of fantasy about the scene, the costumes, or the furniture; the attitudes are perfectly credible and may represent some form of reality. It cannot, however, be ascertained if Preziosi was depicting a place or a scene he had personally witnessed. The harem was considered to be a private and sacred place where no one unauthorized was allowed to enter, not even the husband at certain times. Any kind of debate about it being visited by a non-Muslim man who was not a member of the family, let alone make a picture of it, was inconceivable.

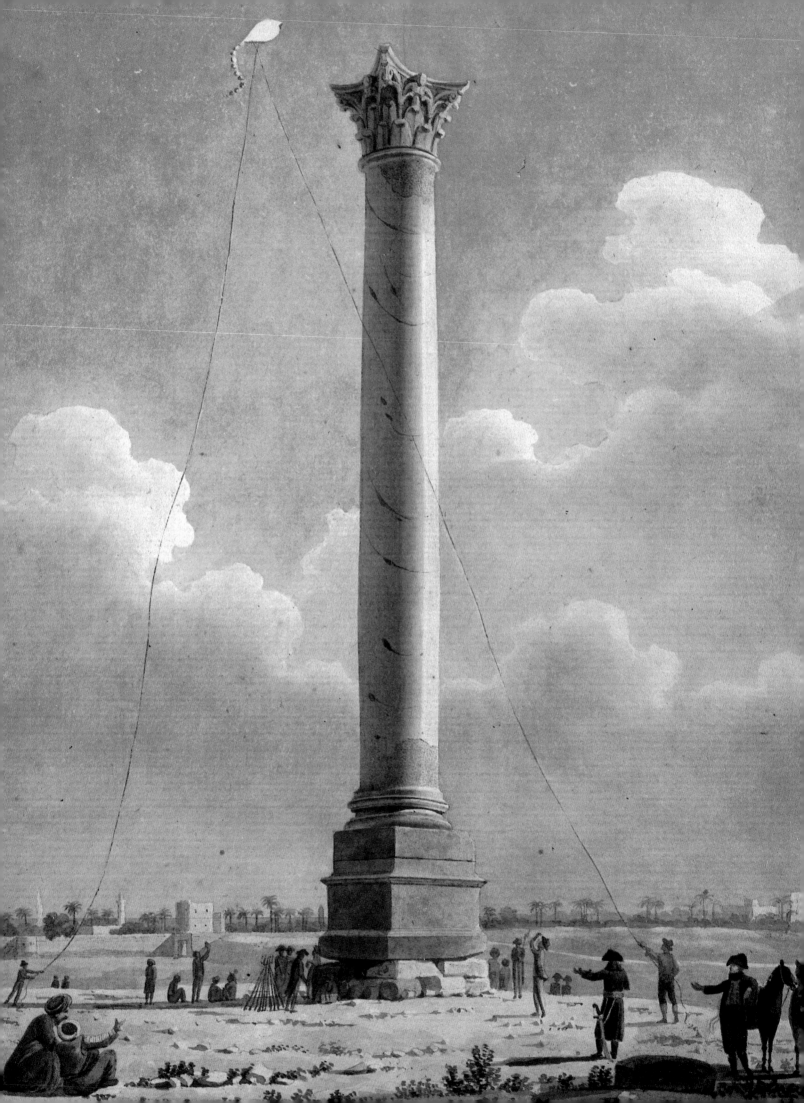

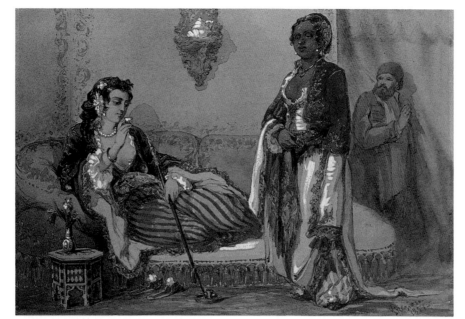

PLATE 60
Interior of a Harem
Amadeo, Fifth Count
Preziosi (1816-1882)
1851
Pencil and watercolor,
heightened with white
18.1 x 26.3 cm

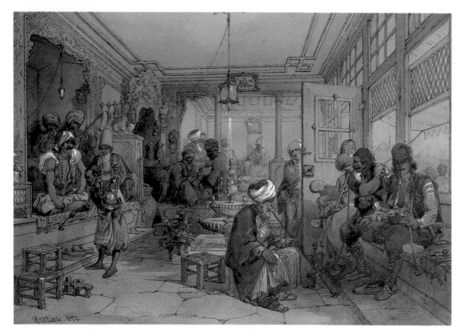

PLATE 61
Coffee House, Istanbul
Amadeo, Fifth Count
Preziosi (1816-1882)
1854
Pencil and watercolor,
heightened with white
40.7 x 58.8 cm

OPPOSITE: PLATE 59
*Pompey's Pillar in
Alexandria*
Baron Dominique Vivant
Denon (1747-1825)
1798
Pencil and watercolor, on
laid paper
21.2 x 26.8 cm

to meet the demand for images generated by tourists and visitors. Yet, if he were motivated only by the desire for money or fame, he would have painted a picture to suit their Western prejudices. In fact, he produced a more sensational version of the same harem picture, dated 1852, allegedly for Empress Eugénie, wife of Napoleon III. In 1858 Preziosi went to Paris and published a set of lithographs of Turkish scenes. These are much nearer to caricature than his paintings, presumably because he was selling works to those Parisians who had never seen the East and wanted something that matched their misconceptions.

Thus in the work of one artist we have several facets of Orientalism, at least three sets of attitudes. At the same time that he was providing the French court with scenes that matched its interpretation of the East, he was compiling a remarkable and chaste album of sensitive portraits of individuals (now in the Victoria and Albert Museum), presumably for his own pleasure, and also painting accurate, colorful scenes as souvenirs for visitors to Istanbul (pls. 8, 25, 61).

European artists were often inspired by the diversity of peoples,

The textiles and decoration of Middle Eastern costume had an enduring impact on Western arts. Drawings by such widely traveled artists as Collins and Goodall inspired the imaginations of painters who had never ventured beyond Europe. *(Pls. 62, 63, 64, 65)*

PLATE 62
Girl with a Fan
William Charles Dobson
RA RWS (1817-1898)
1864
Watercolor and gouache
31.4 x 23.6 cm

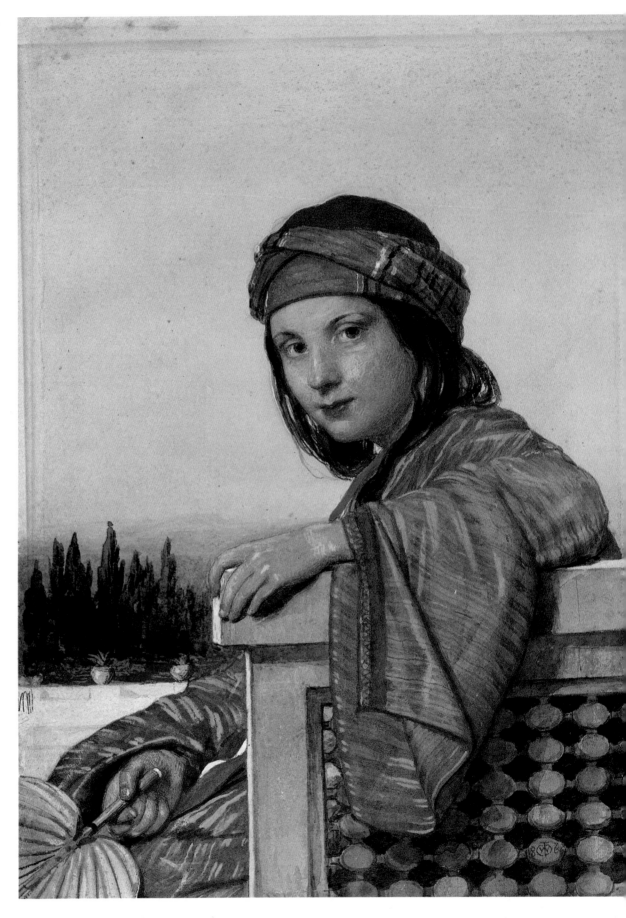

PLATE 63
A Riding Camel
Frederick Goodall RA
(1822-1904)
1893
Pencil and watercolor,
heightened with white
27.3 x 38.9 cm

customs, and costumes of the Middle East. Some artists drew from direct observation, some based their work on existing images, and others created pictures from stories and travelers' accounts, working in their studios with the aid of props. Portrayals of Middle Eastern peoples also differed in purpose, ranging from portraits of individuals and depictions of particular events or ceremonies to contrived fantasies. Twenty-one costume figure studies by William Page (pls. 7, 18, 24) in the Searight Collection show Ottoman and other Middle Eastern characters of various ranks and occupations, both male and female. Having traveled in the region and become aware that European influence was changing traditional forms of dress, Page recorded in detail their exotic, colorful costumes. The clothing worn by the man in Alfred Hassam's *Man in Arab Costume* (pl. 64) was probably put together in the studio from pieces brought back from the Middle East. Little is known about Hassam beyond his being a painter and a designer of stained glass who worked mainly in Birmingham, although he exhibited a few pictures at the Royal Academy in the mid-1860s. William Wiehe Collins rendered *North African Man* (pl. 65) in a skilled "wet" watercolor style that was eminently suited to the vibrant exoticism of the costume. A difficult technique, with little room for error, it gives the feeling of spontaneity, although the brushwork is in fact tightly controlled.

Each painter in the collection had individual and often widely varying attitudes that affected the way he or she painted. Visual responses to antiquities, for instance, ranged from careful delineations of the architectural and decorative features of ruins to less accurate but more vivid views deliberately composed to create a particular pictorial effect. Consider *Theater at Myra* by Louis François Cassas (pl. 66), a skilled draftsman and painter of picturesque landscapes. The ruins represented are recognizable as the theater and tombs of ancient Myra in Lycia (modern Demre on the southwest coast of Turkey), but the lush vegetation and the waterfall fed from the lake are pure fantasy. Here, as in other elaborate watercolors of ruins at Ephesus or Baalbek, painted long after his encounter with them, Cassas focused on the romantic atmosphere of the site rather than on the accurate delineation of its topography. The glory of the natural world combined with the magnificence of the classical past, real or imagined, was more important than mere photographic accuracy. The technique Cassas used, of pen and ink with watercolor,

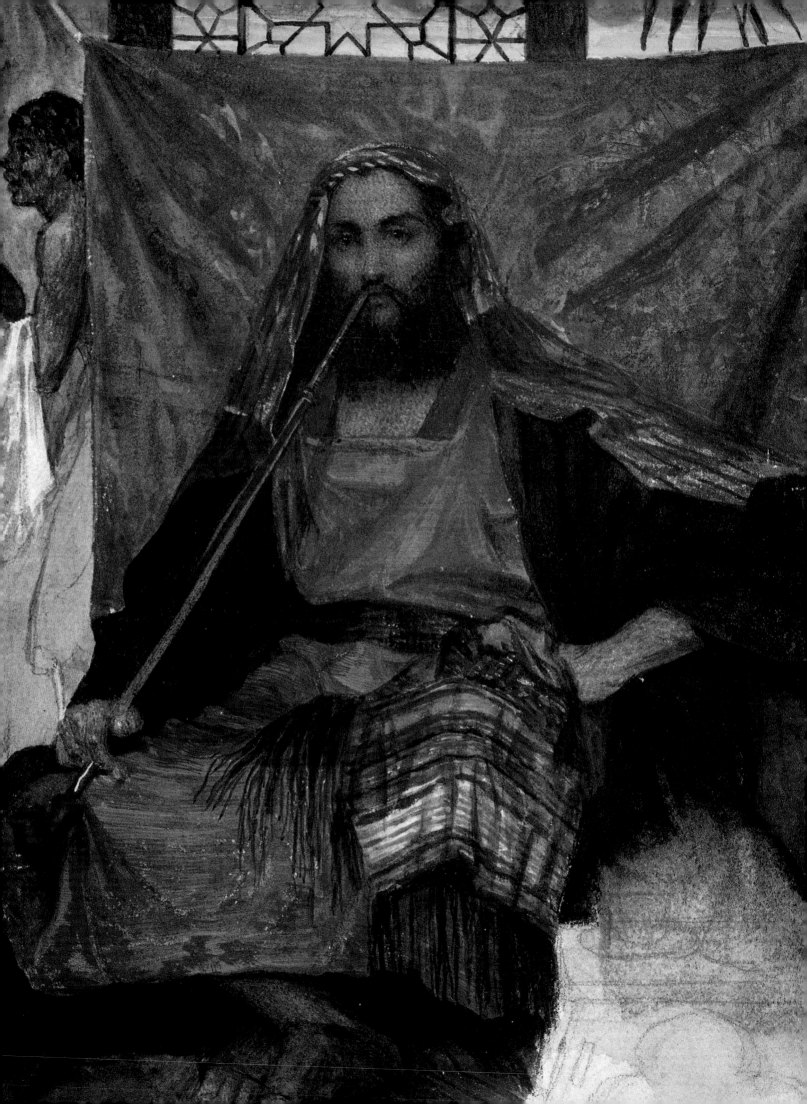

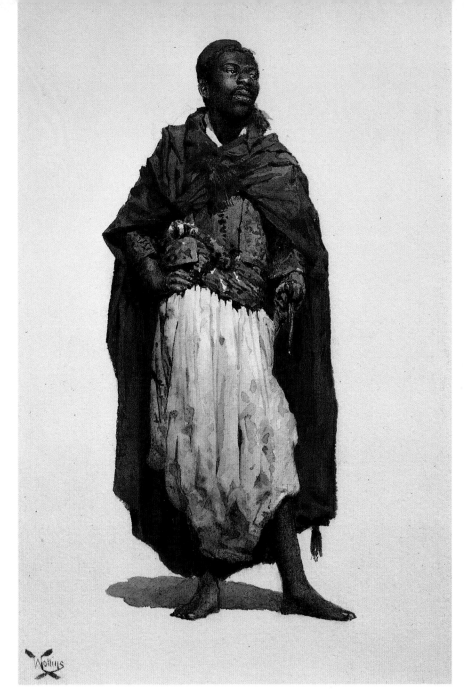

PLATE 65
North African Man
William Wiehe Collins RI
(1862-1951)
c. 1900
Pencil and watercolor,
heightened with white
22.4 x 14.1 cm

OPPOSITE: PLATE 64
Man in Arab Costume
Alfred Hassam (Active
1860s)
c. 1860
Pencil and watercolor,
heightened with white
25.4 x 17.8 cm

was typical of professional training in the second half of the eighteenth century, in which the tinted drawing became the prime way of representing topographical scenes. His picture follows the rule of picturesque composition that dictated ruins should be depicted in a landscape setting with appropriate local figures, or "staffage," to enliven the scene.

In contrast, look at a work by the architect Richard Phené Spiers, which shows the Great Khan, Damascus, in 1866 (pl. 67), painted when he was studying antique as well as Islamic architecture on a Royal Academy Traveling Studentship. The method of depiction is typical of Spiers's training as an architect in the mid-nineteenth century, where the production of accurate, finely detailed and superbly colored, presentation drawings in watercolor was an essential step in convincing a client to build an expensive structure. He shows the splendor and complexity of this sixteenth-century building, which housed many merchants and their goods, with frank admiration for the work of architectural genius. Other artists, Owen Jones, Pascal-Xavier Coste, and Frank Dillon (pls. 68, 69) among them, portrayed Middle Eastern architecture with careful observation and meticulous draftsmanship.

William Simpson's rapid and accurate sketches have the virtues of

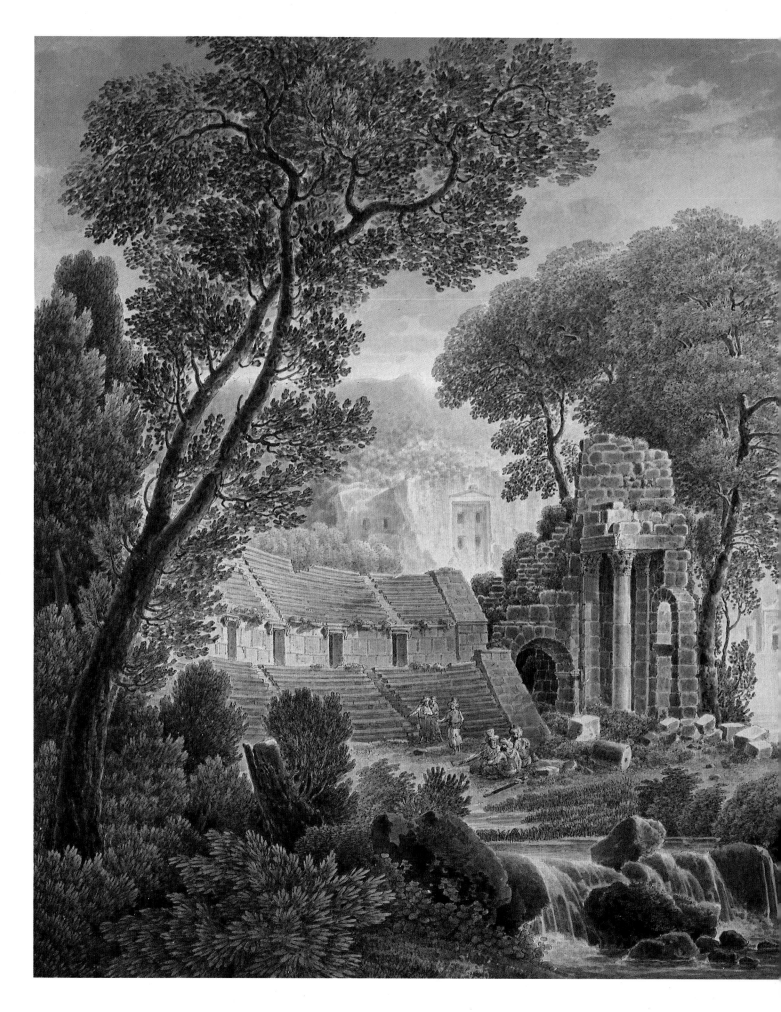

As part of late-eighteenth-century French expeditions that went from southwestern Turkey to Egypt, Cassas delineated the ruins of many ancient civilizations. He later used his drawings to create watercolor compositions evocative of idyllic times.

PLATE 66
Theater at Myra
Louis François Cassas
(1756-1827)
1808
Watercolor, with pen and ink
57.0 x 77.0 cm

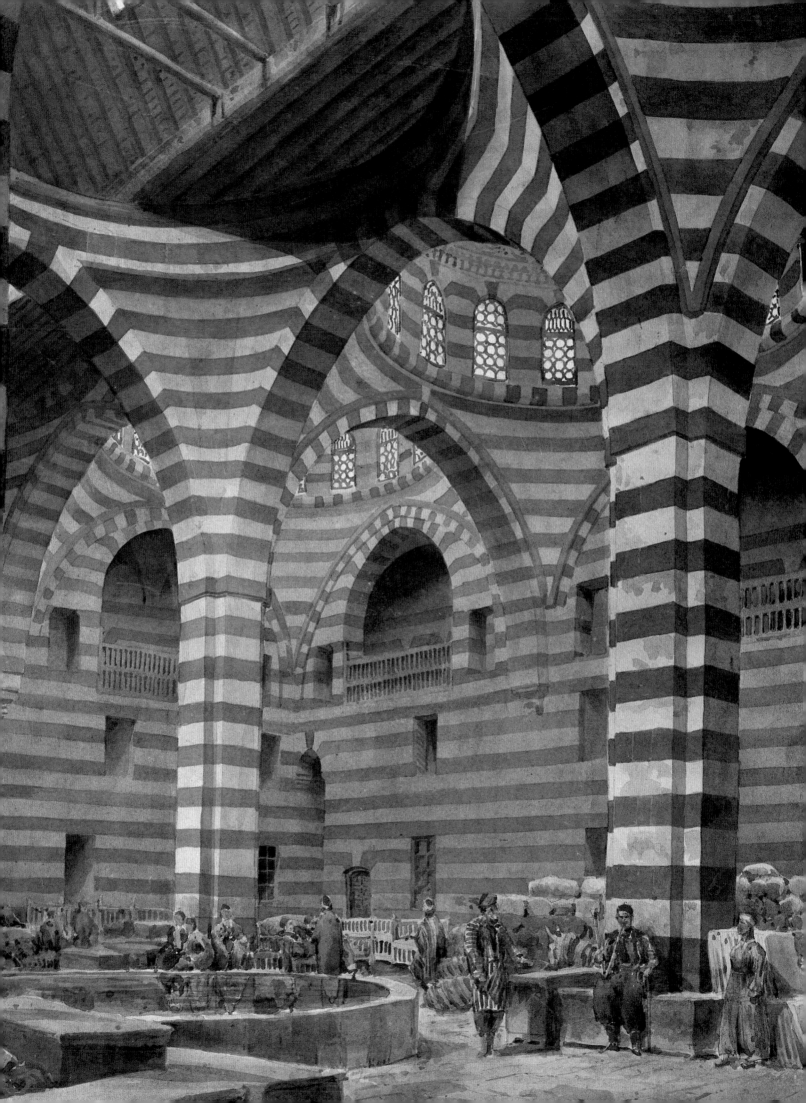

Dillon's passion for the domestic side of architecture and design in Cairo later expressed itself in an "Arab studio" he constructed in his London house and furnished with artifacts carried back from his many trips to the Middle East. *(Pls. 68, 69)*

OPPOSITE: PLATE 67
The Great Khan in Damascus
Richard Phené Spiers
FRIBA FSA (1838-1916)
c. 1866
Pencil and watercolor
36.4 x 25.8 cm

PLATE 68
Interior of a Room in the House of Shaykh Sadat, Cairo
Frank Dillon RI (1823-1909)
c. 1875
Gouache
75.0 x 59.5 cm

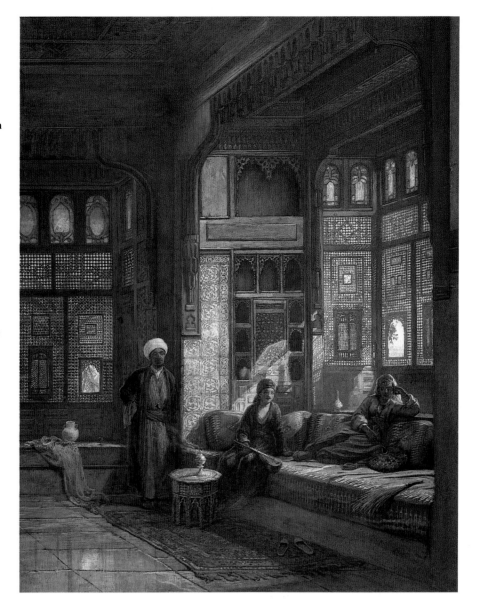

journalism with few of its vices. He is best known now as a war correspondent who reported on the Crimean War while working for the *Illustrated London News*, but he covered many regions of the world in his travels. He was avidly curious about the manners, customs, and religious beliefs of various cultures, sending back his sketches to illustrated newspapers and journals. His trade made him more conscious of the impact of tourism than most of his contemporaries, and he was gently satirical of tourists' excesses. His sketch of the Austrian emperor being hauled up the Pyramid of Cheops by enthusiastic Egyptian guides is amusing enough (pl. 72), but the scene of tourists galloping their donkeys past the antiquities of Luxor in *Heliopolis* (pl. 70) has a sharper edge to it. The local guides and hotels pleaded with tourists "not to gallop the donkeys," but the British sporting types are shown urging their mounts on past the very marvels of the ancient world they had come to see. Simpson was a humane man, interested in comparative religion and both ancient and modern cultures, which is reflected in the diversity of his subject matter.

Maria Harriett Mathias, née Rawstorne, was an amateur, though this term encompasses a whole range of artistic skill, from the very competent (like her) to the completely inept. Because she was an amateur, a tourist, and a woman traveling with her husband and brother-in-law, almost nothing is

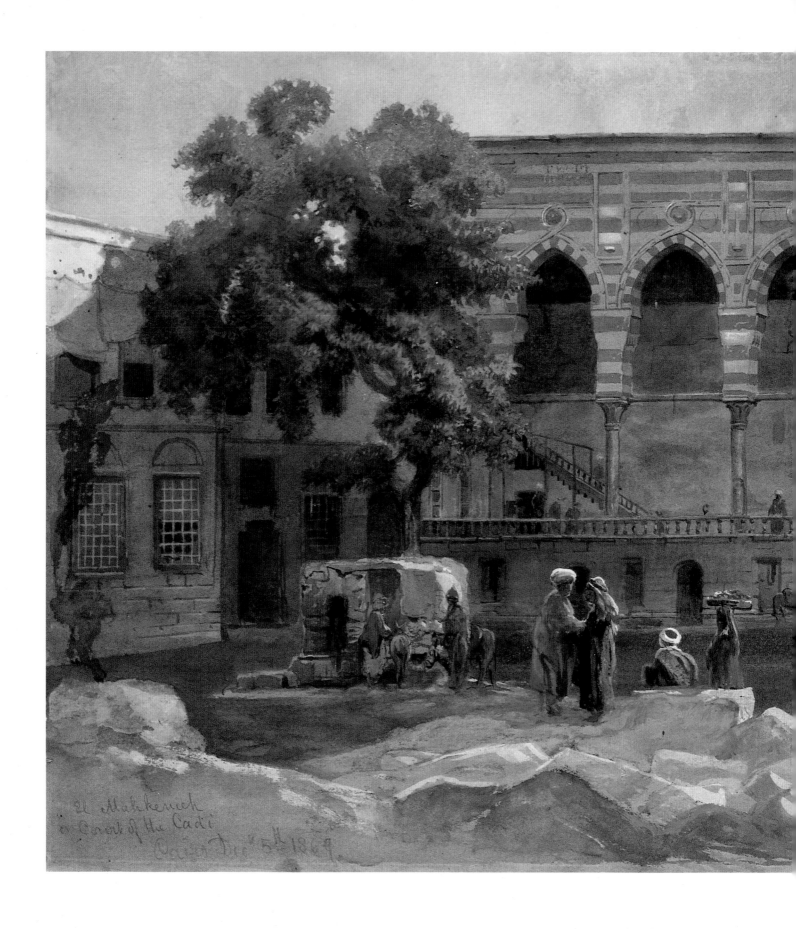

El Mahkemeh
or Court of the Cadi
Cairo Dec 5th 1868

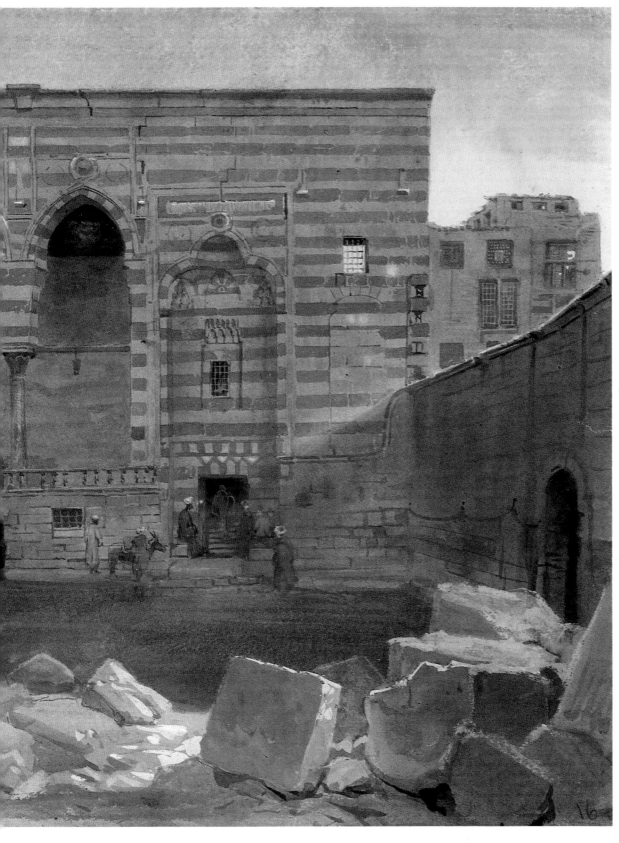

PLATE 69
Loggia of a Mamluk Palace, Cairo
Frank Dillon RI (1823-1909)
1869
Pencil, watercolor, and gouache
29.7 x 52.7 cm

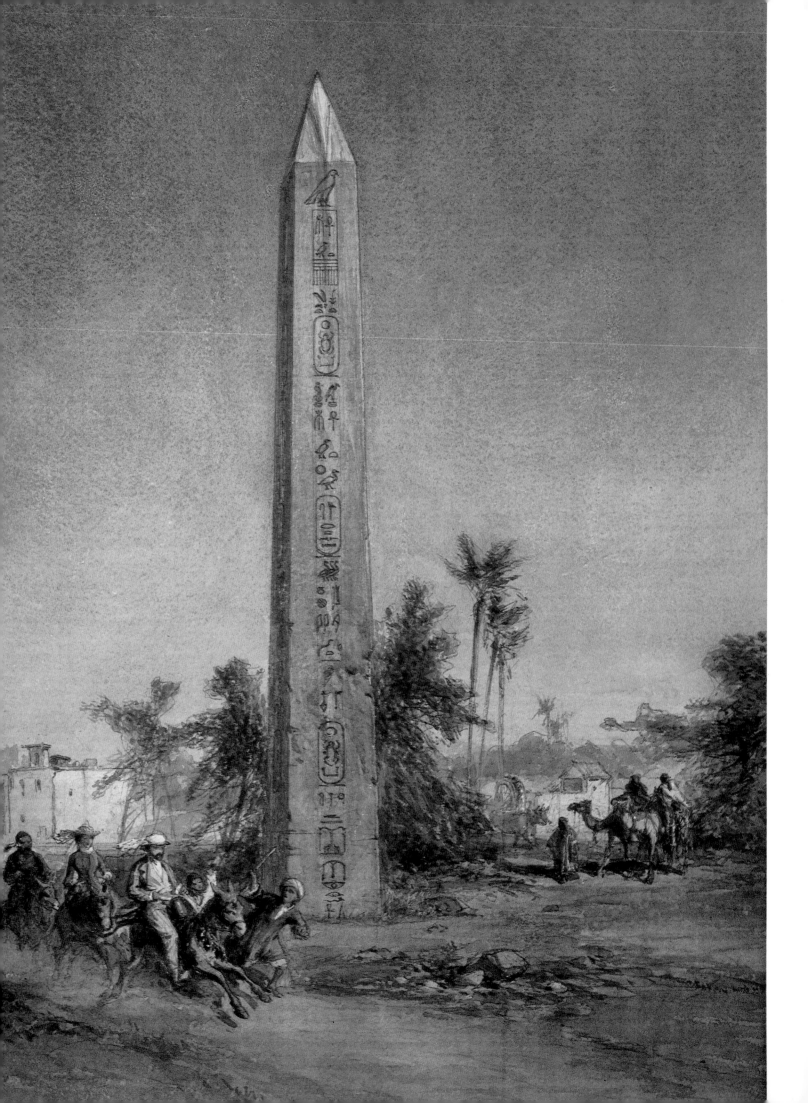

OPPOSITE: PLATE 70
Heliopolis
William Simpson RI
FRGS (1823-1899)
1878
Pencil, watercolor, and
gouache, heightened
with white
37.3 x 26.5 cm

PLATE 71
Street Scene, Cairo
William Simpson RI
FRGS (1823-1899)
1865
Pencil and watercolor,
heightened with white
36.7 x 27.3 cm

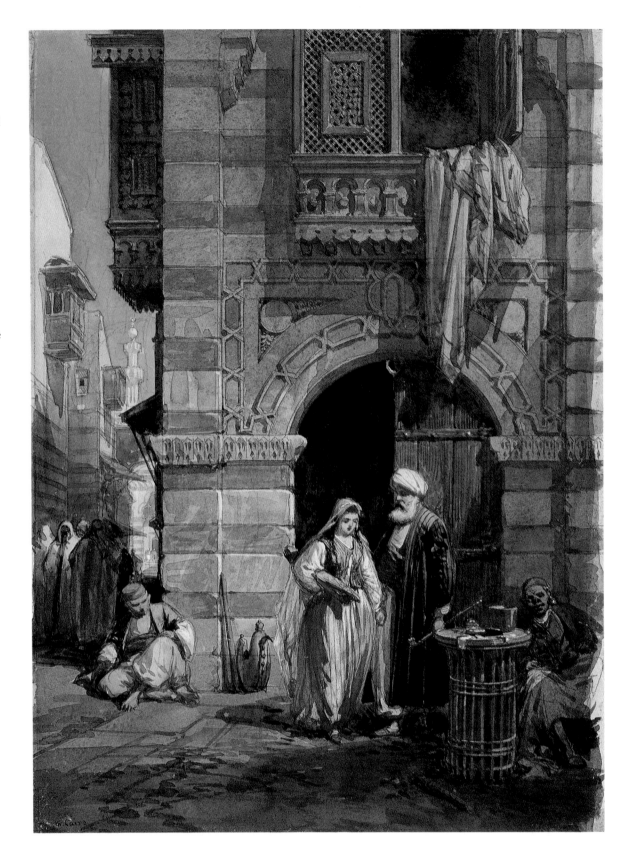

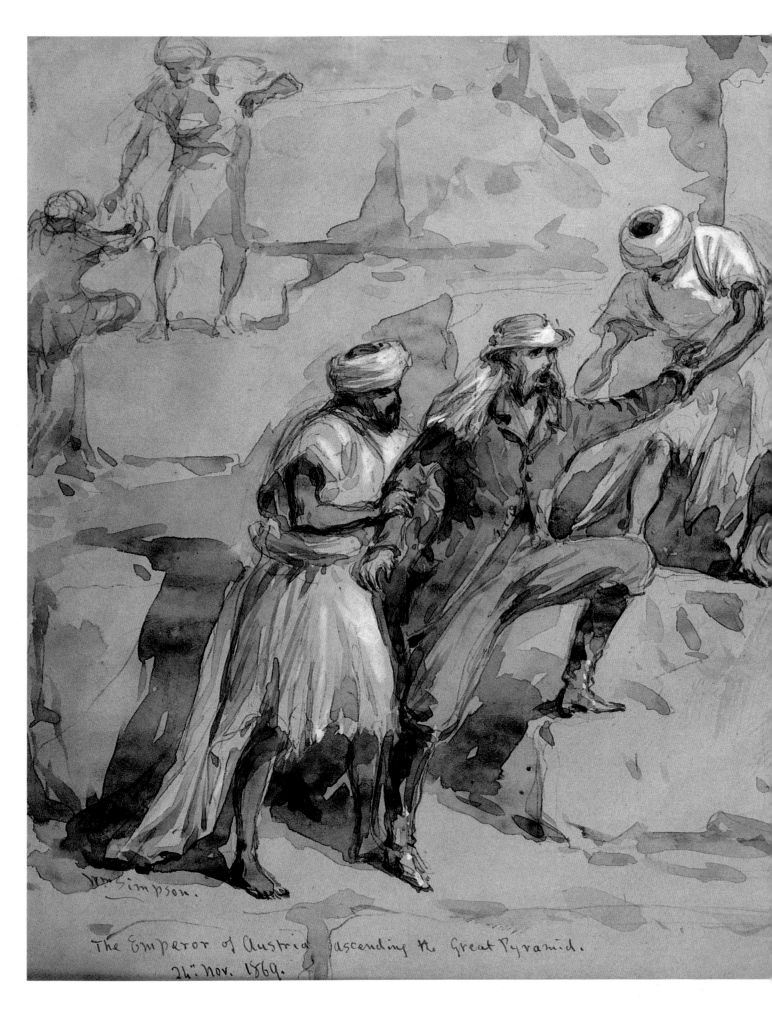

The Emperor of Austria ascending the Great Pyramid.
24ʰ Nov. 1869.

PLATE 72
The Emperor of Austria
Climbing the Pyramid of
Cheops, Giza
William Simpson RI
FRGS (1823-1899)
1869
Pencil and watercolor,
heightened with white
22.1 x 28.0 cm

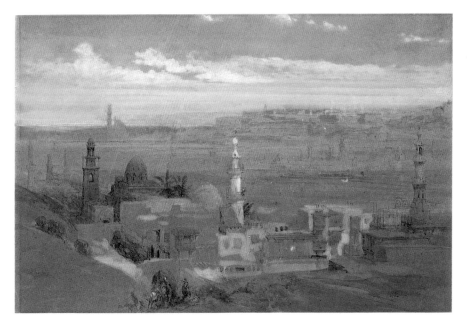

known about her, apart from what a fragment of her diary records and an entry in *Burke's Landed Gentry, 1863*. It is not known where she studied or who taught her art. She belonged to that social class to which painting in watercolors was considered a polite accomplishment, but her skill implies that she regarded painting as a discipline. The picture of the Crusaders' Castle on the Island of Graia (pl. 74) is unique in the Searight Collection, and there are few representations of this scene before the invention of instantaneous photography. Her pictures in the collection, including one of Beirut (pl. 75), are an invaluable record of a vanished world which can never be retrieved, except in the viewer's imagination and with the aid of these images.

David Roberts began his career as a painter of imaginary views. As a scene painter at Drury Lane Theater, he had prepared panoramic backdrops for operas and pantomimes, many in Eastern settings, including the first performance in Britain of Mozart's opera *Abduction from the Seraglio*. Roberts was among the earliest of many professional and independent European artists to journey to the Middle East in search of new and exotic pictorial material, and his 1838-39 tour produced a profusion of sketches of the region's rich and varied aspects. His genius for panoramic views of the East developed rapidly and pervades his later watercolors and oil paintings. Roberts's images of the area became quite popular, and they are still widely known through a series of lithographs that were reproduced from his watercolors and published between 1842 and 1849 as *The Holy Land, Syria, Idumea, Arabia, Egypt and Nubia*.

In his works, Roberts contrasted unfairly, as many Europeans did, the splendor of ancient ruins with the decay and poverty of nineteenth-century Egypt, which had suffered bitterly from the exactions of non-Egyptian rulers. However, his atmospheric sketch of the glories of Cairo (pl. 73), depicts only the magnificence of Islamic architecture and the beauty of the city. Rodney Searight called this striking watercolor, acquired in 1960, the foundation of his collection.

Luigi Mayer had to represent what his patrons wanted. He accompanied Sir Robert Ainslie, the British ambassador to Istanbul, as a paid artist, and at his patron's request, created colorful, dramatic, and picturesque sketches of Middle Eastern scenes. Due to his training in Rome and the influence of Piranesi, Mayer readily incorporated drama into the ruins that he painted. His unorthodox view from the top of the Pyramid of Cheops (pl.

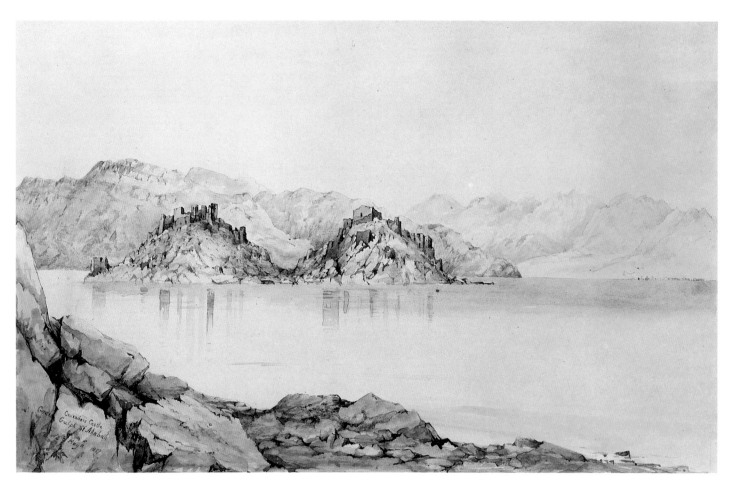

Crusader Castle
Gulph of Akabah
Neph 1857

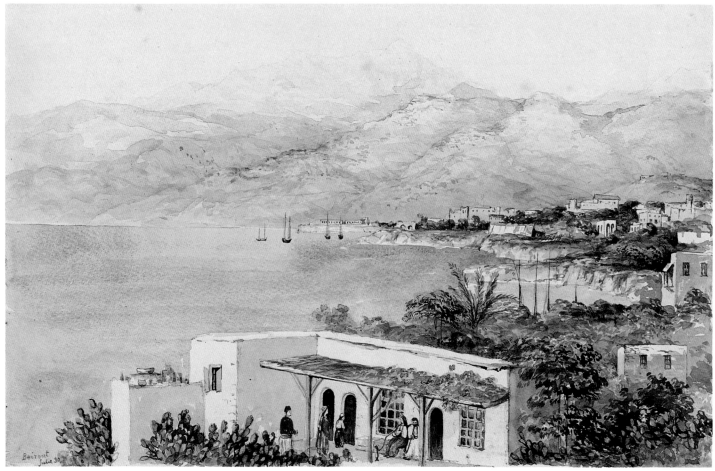

Beirout
July 30

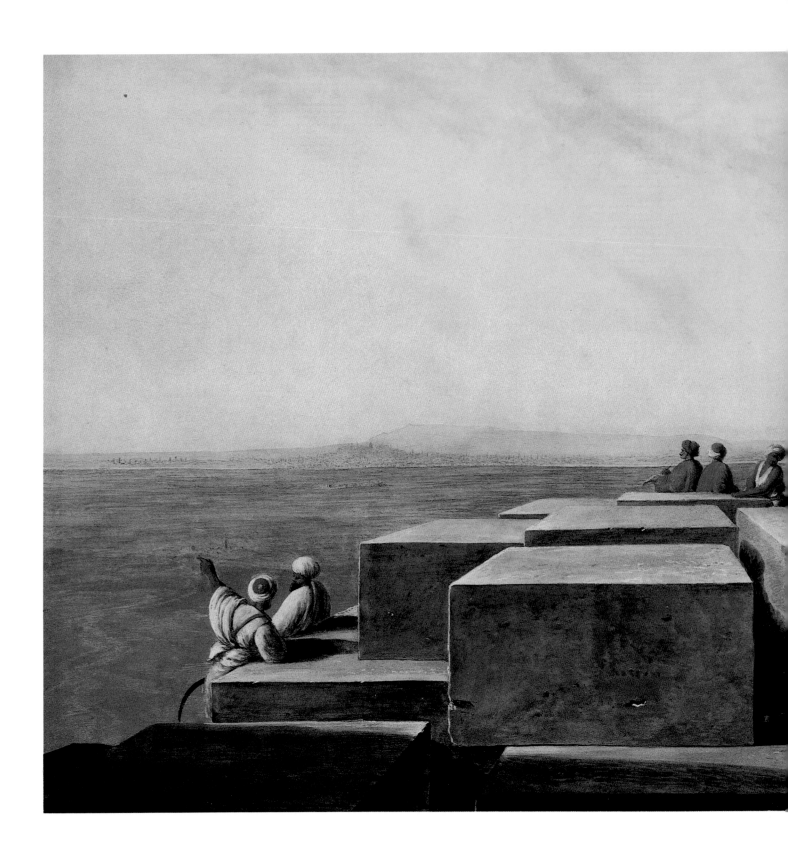

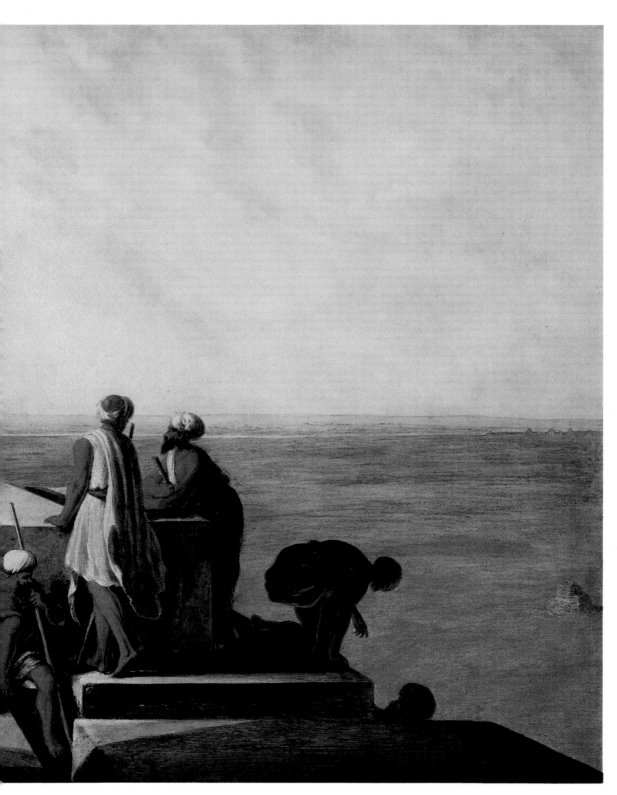

PLATE 76
Cairo from the Summit of the Pyramid of Cheops, Giza
Luigi Mayer FSA
(c. 1750-1803)
c. 1800
Watercolor and gouache, heightened with white
56.4 x 90.7 cm

More than any other region of the Middle East, the area surrounding the Nile River in Egypt attracted European travelers in the nineteenth century. Owing to the long reign of Muhammad Ali, who was open to contacts with the West, and the allure of ancient Egypt, the Nile from Alexandria to Aswan became host to a diverse cast of traveling artists. These artists encountered ruins of monuments, temples, and tombs that had often been occupied and transformed in the interceding centuries. *(Pls. 77, 78, 79)*

PLATE 77
Studies of Mummy Cases and Mummies
Edward Angelo Goodall
RWS (1819-1908)
c. 1870
Pencil and watercolor, heightened with white
25.4 x 35.6 cm

PLATE 78
Interior of the Temple of Medinet Habu, near Luxor
Captain Charles Francklin Head (1796-1849)
c. 1830
Pencil, with pen, ink, and wash
27.5 x 41.2 cm

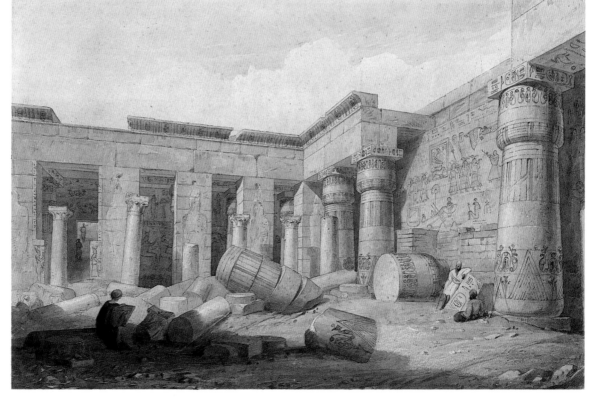

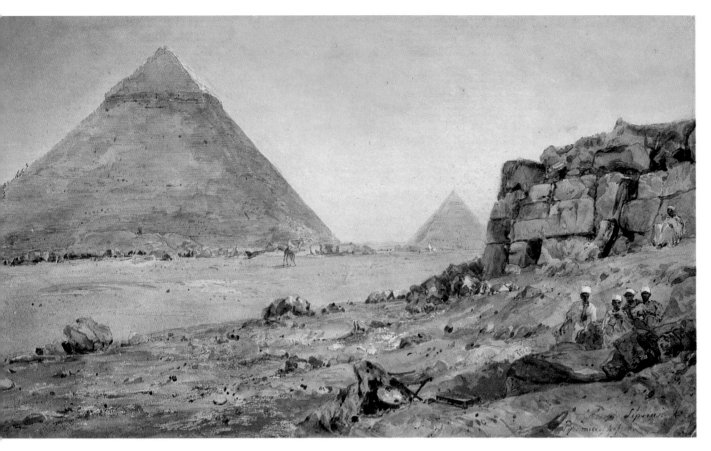

76) was on an heroic scale for a watercolor sketch and satisfied the curiosity of armchair travelers, many of whom must have wondered just what it was like to stand at the top of such a huge and ancient structure. The large figures grouped on the enormous cut blocks of the ancient pyramid form a striking contrast to the outstretched desert with the outline of nineteenth-century Cairo in the distance. A series of volumes of "views" by Mayer of the antiquities, landscape, and people of the Ottoman Empire was published as aquatints between 1801 and 1810.

Very little is known about Mayer, because he was an employee, on the staff, as it were, as Sir Robert's painter, which placed him in the same category as the other servants. Mayer did not, alas, keep a diary, or it has not survived. It is pleasant to remember, however, that it is his work that has proved enduringly popular. Mayer's color-drenched gouache style is typical of his Roman training in topographical drawing, and the bravura of many of his representations came naturally to him, as that was the ethos in which his painting matured. He died quite young, before his style went out of fashion, and his widow Clara made a living by painting in the same manner. Mayer's Orientalism is mediated by the conventional subjects that his patron demanded, but the sheer zest of his representations made him, with David Roberts, one of the day's most popular painters of Middle Eastern subjects.

With these few examples we merely touch the surface of a rich field for investigation; such a brief examination of the pictures in the collection could be expanded in many directions. A close study of techniques and subject matter, combined with an in-depth look at the artists' motivations and the constraints which underlay various representations, offers many rewards. As more is discovered about the artists in the collection—and there is a large amount of material untapped as yet—the perception of Orientalist painting will change, and the Searight Collection will be of increasing importance in this process.

PLATE 79

Pyramid of Chephren, Giza

Pierre Henri Theodore Tetar van Elven (1828-1908)

c. 1880

Pencil and watercolor, heightened with white

31.2 x 53.4 cm

Artists emphasized the notable characteristics of each site they drew. At al-Dayr, Lear focused on the monumental rock-cut piers of the temple forecourt. Lindsay's watercolor details one of the few surviving temple roofs in Egypt. The columned kiosk to the left rear corner of the roof is an especially important detail, suggesting that ceremonial pathways in the temple might end on the roof itself. *(Pls. 80, 81, 82)*

PLATE 80
Roof of the Temple of Hathor at Dandara
Lady Jane Evelyn Lindsay (1862-1948)
1896
Pencil and watercolor, heightened with white, on green paper
23.0 x 35.0 cm

PAGES 120-121: PLATE 81
Colossi of Memnon at Thebes
Anonymous
Early 19th century
Pencil and watercolor, with pen and ink
28.7 x 46.1 cm

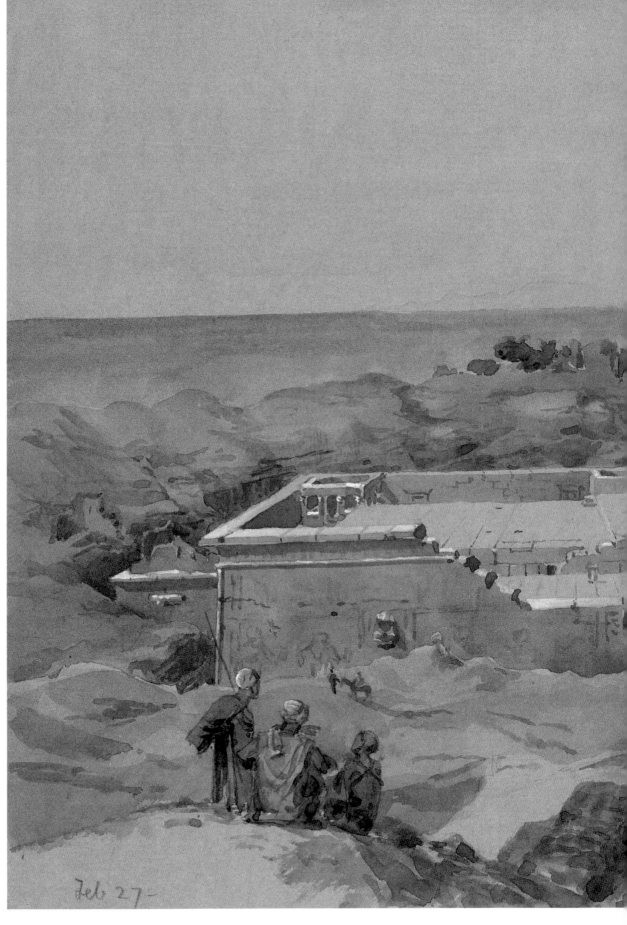

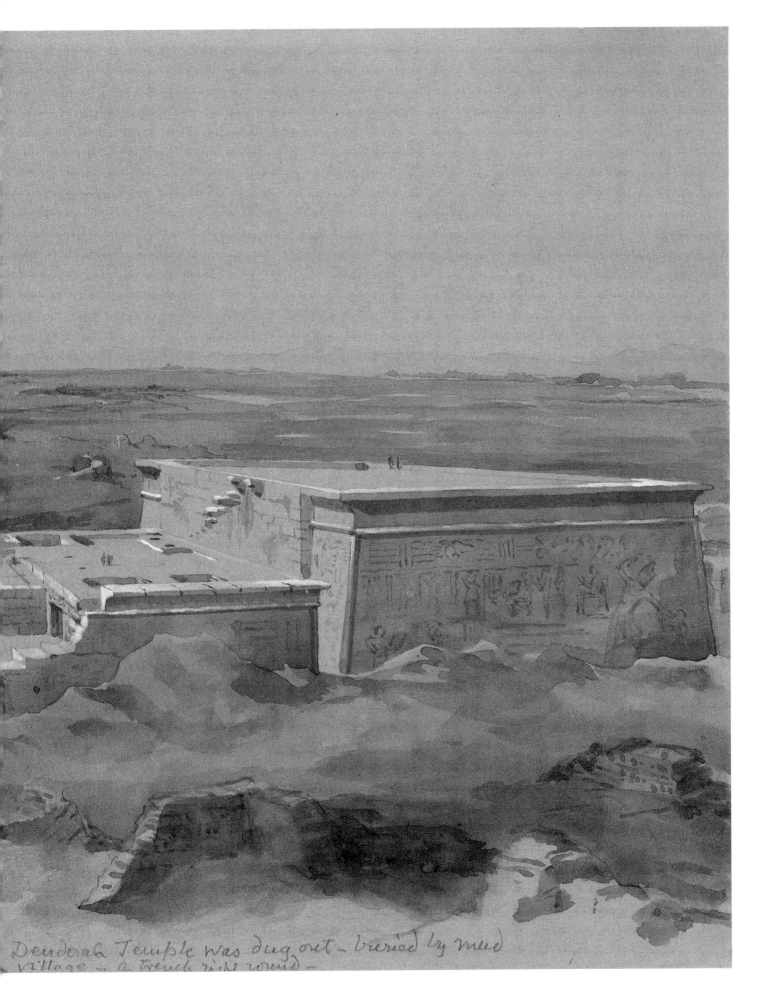

Dendorah Temple was dug out – buried by mud
village – a trench right round –

119

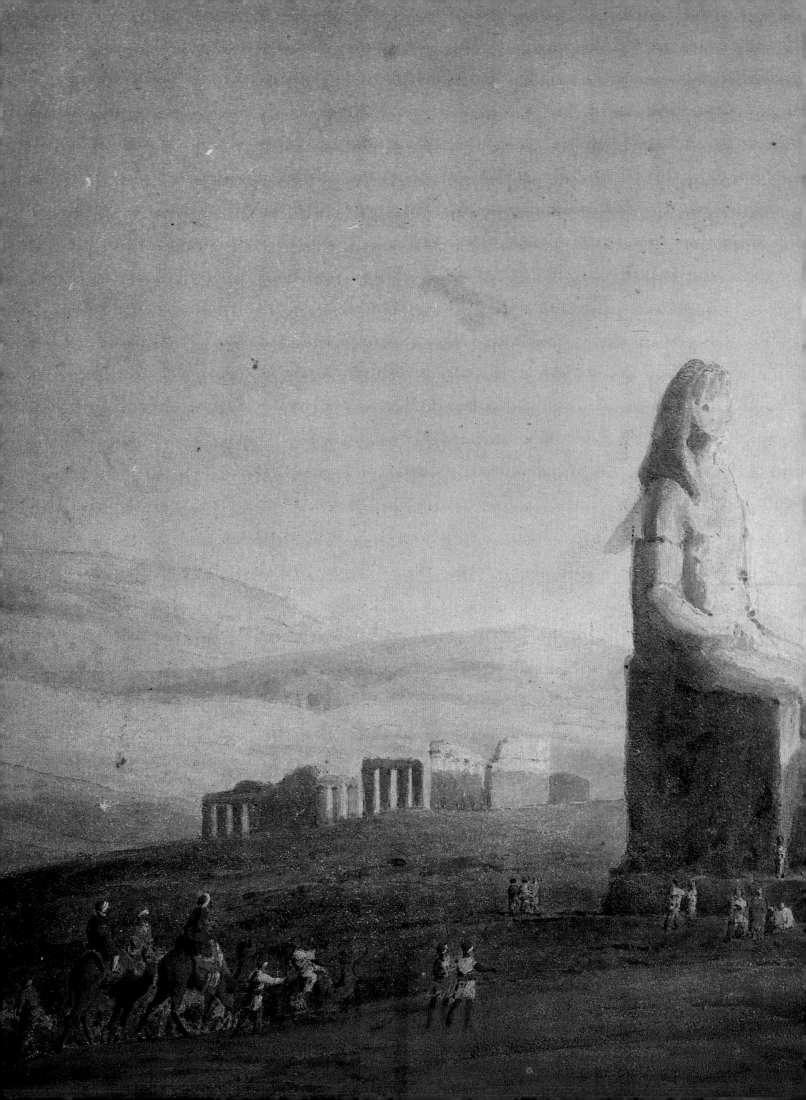

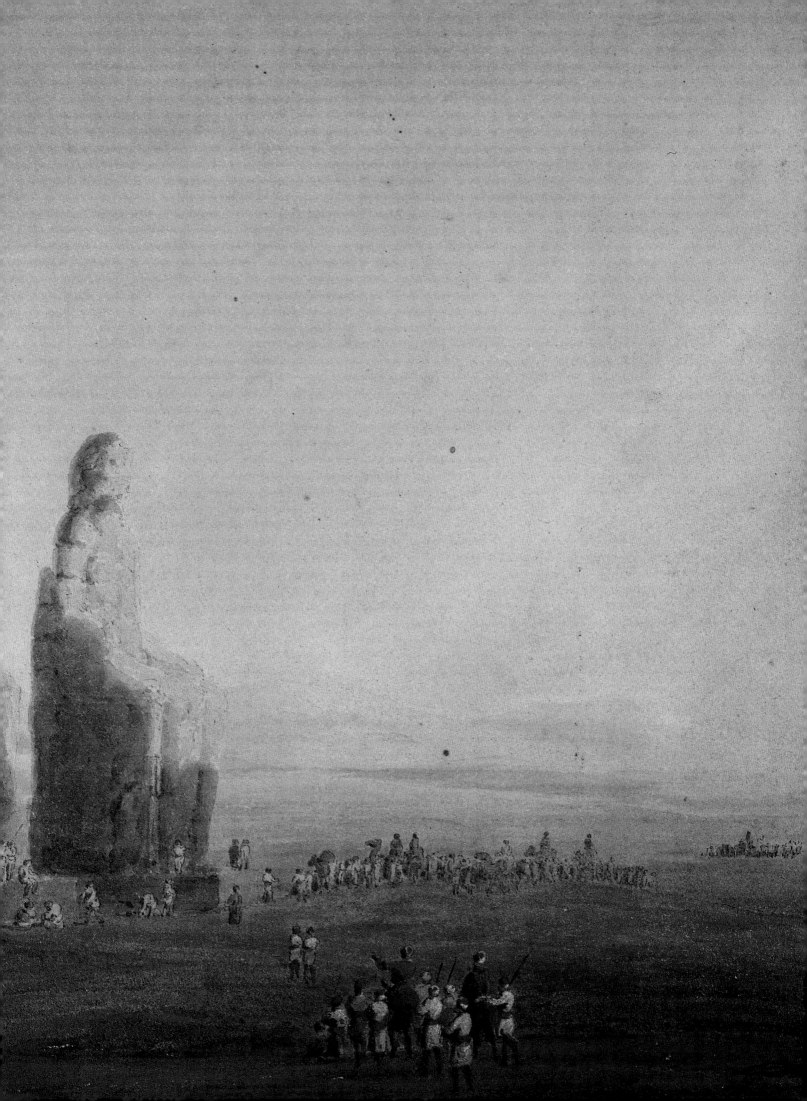

Derr.
4 P.M. 11 Febr 1867.

122

PLATE 82
Temple Ruins at Al-Dayr
Edward Lear (1812-
1888)
1867
Pencil and watercolor,
with pen and ink
34.4 x 50.5 cm

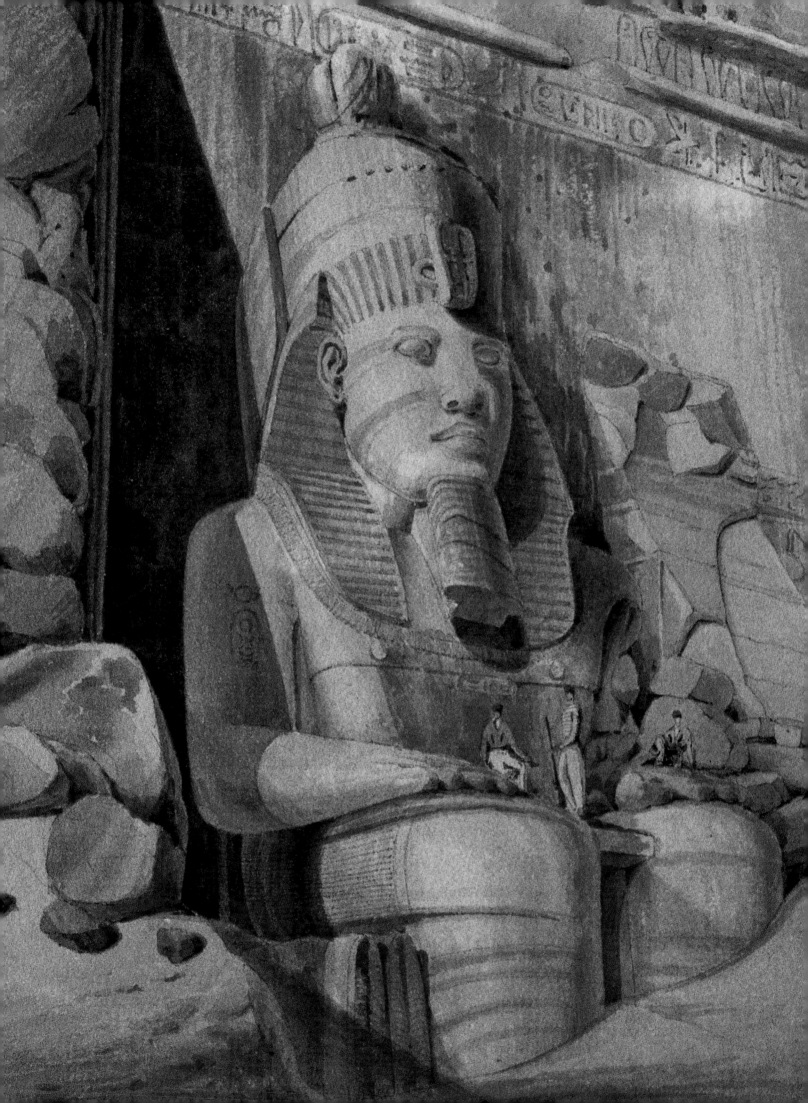

ACKNOWLEDGEMENTS

Anna R. Cohn

...forth suddenly came the Rameses Heads!! I was absolutely too astonished and affected to draw....As a whole the scene is overpowering from its beauty—colour—solitude—history—art—poetry—every sort of association...all other visible things in this world seem to be as chips, or potatoparings, or any nonsense in comparison.

—Edward Lear at the Temple of Rameses II, Abu Simbel, 1867

Diverse and dramatic, the lands and cultures of the Middle East have, over time, elicited a variety of visual responses from artists. *Voyages and Visions* presents European artists' encounters with the region during the hundred years preceding the enormous transformations of the twentieth century. The drawings and watercolors in the exhibition offer a prelude to the rapid development and growth characteristic of the modern Middle East. The works come from the extensive Searight Collection at the Victoria and Albert Museum, and SITES is honored to introduce a select portion of the collection to audiences in the United States.

Anna R. Cohn is the Director of the Smithsonian Institution Traveling Exhibition Service.

No international exhibition today succeeds without considerable corporate and foundation support. We are thankful to the Boeing Company and the Boeing Commercial Airplane Group for providing the funding that made this show possible. To Shell International Petroleum Company Limited, we are thankful for funds in support of the publication, and we especially thank Julian Paxton, who as part of the company's Group Public Affairs endorsed our intention to tour these works in this country. Thanks also to The British Council for its advice and support; we would like to recognize in particular the effort of David Evans, Cultural Attache, and his predecessor in that post, Gordon Tindale. We are grateful to the Drue Heinz Foundation for additional support.

At the Victoria and Albert Museum, we would like to extend thanks to former Director Elizabeth Esteve-Coll, and Gwyn Miles, Surveyor of Collections. Charles Newton, Deputy Head of Designs in the Department of Paintings, Drawings, and Prints, was a curator of the exhibition and generously provided help and expertise. We also thank the Registrar, Hilary Bracegirdle, for all her assistance.

The *Voyages and Visions* project team at SITES was headed by Donald Roberts McClelland, Assistant Director for Programs, who was assisted by Jeffrey Thompson and Mary Sipper, Project Directors, and Fredric P. Williams, Registrar. Research for the exhibition was based in part on the work of Briony Llewellyn, former archivist of the Searight Collection, and furthered by the contributions of Gregory Naranjo, Melissa Stegeman, Donna Hadjikhani, and Sally Hoffmann.

The publication for *Voyages and Visions* was much enriched by the contributions of its essayists: Dr. Esin Atıl, specialist of Islamic arts and cultures, Arthur M. Sackler Gallery and Freer Gallery of Art, Smithsonian Institution; Sarah Searight, a Middle East specialist and Islamic art historian; and Charles Newton. The publication was directed by Andrea Stevens, Associate Director for External Relations, SITES, and edited by Elizabeth Kennedy Gische, Editor, SITES. Nancy Eickel provided editorial assistance.

DETAIL OF PLATE 42
Temple of Rameses II at Abu Simbel

Bibliography

Donald McClelland

Ballantine, James. *The Life of David Roberts, R.A., Compiled from his Journals and Other Sources*. Edinburgh, 1866.

Galey, John. *Sinai and the Monastery of St. Catherine*. Garden City, New York, 1980.

Jullian, Philippe. *The Orientalists: European Painters of Eastern Scenes*. Oxford, 1977.

Laing Art Gallery. *John Frederick Lewis*. Newcastle-upon-Tyne, 1971.

Noakes, Vivien. *Edward Lear: The Life of a Wanderer*. London, 1968.

Esin Atil

Boppe, M.A. *Les Peintres du Bosphore au XVIII Siècle*. Paris, 1911.

Cezar, Mustafa. *Sanatta Batı'ya Açılış ve Osman Hamdi* (Opening to the West in Art and Osman Hamdi). Istanbul, 1971.

Celik, Zeynep. *Displaying the Orient: Architecture of Islam at Nineteenth-Century World Fairs*. Berkeley, 1992.

_____. *The Remaking of Istanbul: Portrait of an Ottoman City in the Nineteenth Century*. Seattle, 1986.

Germaner, Semra, and Zeynep Inankur. *Orientalism and Turkey*. Istanbul, 1989.

Holod, Renata, and Ahmet Evin, eds. *Modern Turkish Architecture*. Philadelphia, 1984. See in particular chapter 2, "The Final Years of the Ottoman Empire," by Yıldırım Yavuz and Suha Özkan, pp. 34-50.

Pınar, Selman, et al. *A History of Turkish Painting*. Seattle, 1989.

Raby, Julian. *Venice, Dürer and the Oriental Mode*. London, 1982.

Renda, Günsel. *Batılılaşma Döneminde Türk Resim Sanatı 1700-1850* (Turkish Painting during the Period of Westernization). Ankara, 1977.

Rouillard, Clarence Dana. *The Turk in French History, Thought, and Literature (1520-1660)*. Paris, 1938.

St. Clair, Alexandrine N. *The Image of the Turk in Europe*. New York, 1973.

Thalasso, Adolphe. *L'Art Ottoman: Les Peintres de Turquie*. Istanbul, 1988 (reprint of Paris 1910 ed.).

Sarah Searight

Ahmad, Laila. *British Ideas of the Middle East in the Nineteenth Century*. Cambridge, England, 1978.

Avery, P. *Modern Iran*. New York, 1965.

Bartlett, W.H. *Bible Scenes of Interest and Beauty*. London, 1858.

_____. *Footsteps of Our Lord. . . .* London, 1852.

_____. *Forty Days in the Desert*. London, 1849.

_____. *Gleanings on the Overland Route*. London, 1851.

_____. *Jerusalem Revisited*. London, 1855.

_____. *The Nile Boat*. London, 1850.

_____. *A Pilgrimage Through the Holy Land*. London, 1850.

_____. *Walks About the City*. London, 1844.

Biddulph, William. *Travels . . . into Africa, Asia, etc.* London, 1609.

Bruyn, Cornelius de. *Voyage to the Levant*. London, 1702.

Cartwright, John. *The Preacher's Travels*. London, 1611.

Chardin, John, Sir. *Journal du voyage . . . en Perse*. Paris, 1686.

Charles-Roux, Jules. *L'Isthme et le canal de Suez*. 2 vols. Paris, 1901.

Chew, Samuel. *The Crescent and the Rose*. New York, 1937.

Clayton, P. *The Rediscovery of Ancient Egypt: Artists and Travellers in the Nineteenth Century*. London, 1982.

Cromer, Earl of. *Modern Egypt*. 2 vols. London, 1908.

Denon, Dominique Vivant, *Voyage dans la basse et la haute Egypte*. Paris, 1802.

Duff Gordon, Lucie. *Letters from Egypt*. London, 1865; new ed. edited by Sarah Searight, London, 1983.

Foster, William, Sir. *England's Quest of Eastern Trade*. London, 1933.

Greaves, R.L. *Persia and the Defence of India*. London, 1959.

Hopkirk, Peter. *The Great Game*. London, 1990.

Hoskins, Harold. *British Routes to India*. London, 1928.

Hourani, Albert. *The Emergence of the Middle East*. London, 1981.

Issawi, Charles. *The Economic History of the Middle East 1800-1914*. Chicago, 1966.

Lane, Edward. *Manners and Customs of the Modern Egyptians*. London, 1840.

Layard, Austen Henry. *Nineveh and Babylon*. London, 1853.

Lear, Edward. *Letters*. Edited by Lady Constance Strachey. London, 1907.

Lewis, Bernard. *The Emergence of Modern Turkey*. London, 1961.

Lewis, Michael. *John Frederick Lewis, R.A., 1805-1876*. Leigh-on-Sea, 1978.

Llewellyn, B. *The Orient Observed*. London, 1990.

Madden, R.R. *Egypt and Mohammed Ali*. London, 1841.

Masson, P. *Histoire du commerce français dans le Levant au 17e siècle*. Paris, 1896.

Maundrell, Henry. *A Journey from Aleppo to Jerusalem*. London, 1707.

Moryson, Fynes. *Itinerary*. London, 1617.

Owen, Roger. *The Middle East in the World Economy 1800-1914*. London, 1981.

Pococke, Richard. *A Description of the East*. London, 1743-1745.

Pudney, John. *Thomas Cook*. London, 1958.

Purchas, Samuel. *Purchas his Pilgrimes*. London, 1655.

Roberts, David. *The Holy Land, Egypt, Arabia and Syria*. London, 1842-1849

Sandys, George. *A Relation of a Journey*. London, 1615.

Searight, Sarah. *The British in the Middle East*. London, 1979.

_____. *Steaming East*, London, 1991.

St. John, J.A. *Egypt and Muhammad Ali*. London, 1834.

Steegmuller, F. *Flaubert in Egypt*. London, 1972.

Twain, Mark [Samuel Clemens]. *The Innocents Abroad*. New York, 1869.

Volney, Constantin-François. *Voyage en Syrie et en Egypte*. Paris, 1787.

Wood, A.C. *A History of the Levant Company*. London, 1964.

Wood, Robert. *The ruins of Palmyra, otherwise Tadmor*. London, 1753.

_____. *The Ruins of Baalbek*. London, 1757.

Yapp, M.E. *The Making of the Modern Middle East 1792-1923*, London, 1987.

Charles Newton

Juler, Caroline. *Les Orientalistes de l'Ecole Italienne*. Paris, 1987.

Llewellyn, Briony, and Charles Newton. *The People & Places of Constantinople*. London, 1985.

Lowe, Lisa. *Critical Terrains: French and British Orientalisms*. Ithaca, New York, 1992.

Roberts, David. *Eastern Journal*. Unpublished transcript by Christine Bicknell. 2 vols. National Library of Scotland.

Said, Edward. *Orientalism*. New York, 1978.

INDEX OF ARTISTS

SD (Searight Drawing) followed by a number indicates the Victoria and Albert Museum inventory number of the work.

The captions accompanying the illustrations in VOYAGES AND VISIONS: NINETEENTH-CENTURY EUROPEAN IMAGES OF THE MIDDLE EAST FROM THE VICTORIA AND ALBERT MUSEUM *are based on the catalogue of the Searight Collection published on microfiche in conjunction with the color and black-and-white microfiche illustrations of the entire collection. The Searight Collection forms Part I-III of* THE MUSLIM WORLD, *a microfiche, produced by Emmett Publishing Limited, of images of the Middle East by European artists, housed in the Prints, Drawings, and Paintings Collection at the Victoria and Albert Museum.*

VOYAGES & VISIONS

NINETEENTH-CENTURY EUROPEAN IMAGES OF THE MIDDLE EAST

FROM THE VICTORIA AND ALBERT MUSEUM

Prepared by the Smithsonian Institution Traveling Exhibition Service
Andrea Stevens, Associate Director for External Relations
Edited by Elizabeth Kennedy Gische
Produced by Perpetua Press, Los Angeles
Designed by Dana Levy and James Schlesinger
Typeset on a Power Macintosh computer using Bitstream Charter for the text
Printed in Hong Kong by C&C Offset Printing Co.